THE FASHION ICONS

DIOR

Written by
Michael O'Neill

© Danann Media Publishing Limited 2023

First Published Danann Media Publishing Limited 2023

WARNING: For private domestic use only, any unauthorised Copying, hiring, lending or public performance of this book is illegal.

CAT NO: SON0574

Photography courtesy of

Getty images:

Keystone-France/Gamma-Rapho	Jack Garofalo/Paris Match	Keystone
Victor Virgile/Gamma-Rapho	Francois Pages/Paris Match	Roger Wood/Picture Post
- / AFP	Mondadori	Hulton Archive
Angela Weiss/AFP	Staff/AFP	Roger Wood
Michel Laurent/Gamma-Rapho	Keystone-France/Gamma-Keystone	Chicago History Museum
Harry Croner/ullstein bild	Roger Viollet	JTBC PLUS/Imazins
Bettmann	Savitry/Picture Post/Hulton Archive	Indianapolis Museum of Art
Ken Faught/Toronto Star	Luigi Diaz/General Photographic Agency	

Alamy:

dpa/Alamy Live News	Rachel Royse	PA Images
Thierry Orban/abacapress.com	Malcolm Park/Alamy Live News	World History Archive
Jonas Gustavsson/Sipa USA	TCD/Prod.DB	Granger - Historical Picture Archive
Imaginechina Limited	Pictorial Press Ltd	Keystone Press
A. Astes	Everett Collection Inc	Chroma Collection

Other images, Wiki Commons

Book design Darren Grice at Ctrl-d
Editor Carolyn McHugh
Additional writing by Carolyn McHugh
Proof reader Juliette O'Neill

All rights reserved. No Part of this title may be reproduced or transmitted in any material form (including photocopying or storing it in any medium by electronic means and whether or not transiently or incidentally to some other use of this publication) without the written permission of the copyright owner, except in accordance with the provisions of the Copyright, Designs and Patents Act 1988. Applications for the copyright owner's written permission should be addressed to the publisher.

This is an independent publication and it is unofficial and unauthorised and as such has no connection with Dior or any other organisation connected in any way whatsoever with Dior featured in the book.

Made in EU.
ISBN: 978-1-915343-31-4

CONTENTS

AN UNEASY CHILDHOOD. 1905-1913 8
PARADISE LOST AND FOUND. 1914-1920 14
LIFE ON THE EDGE. 1920 18
THE PARALLEL LIVES OF CHRISTIAN. 1921-1930 22
OFF AT A TANGENT. 1927-1930 26
A FAMILY IN TURMOIL. 1928-1932 30
ONE STEP DOWN, ONE STEP UP. 1932-1939 32
DARKNESS DESCENDS. 1939-1945 38
ASCENT INTO THE LIGHT. 1945-1946 42
ONE NIGHT IN PARIS. 1946-1947 48
THE GIDDY HEIGHTS. 1947 58
GLAMOUR GALORE! 64
DIOR'S QUEENS OF THE DAY. 72
GO WEST, MIDDLE-AGED FRENCHMAN! 1947 78
THE GLOSS TURNS GLOBAL. 1948-1953 84
PRÊT-À-DIOR. 1952-1953 94
THIS TERRIBLE, WONDERFUL PUBLIC. 1954-1957 100
THOSE WHOM THE GODS LOVE. 1957 114
EPILOGUE 124

AN UNEASY CHILDHOOD 1905-1913

"Individuality will always be one of the conditions of real elegance."

Christian Dior was born in Granville, France, on 21 January 1905, the second child of Maurice and Madeleine Dior.

Maurice was a successful industrialist, who ran a fertilizer and chemicals manufacturing business, called Dior Frères, which provided the family with a comfortable living. Working with his brother Henry, Maurice became a successful businessman by building up and expanding his father's business so that by the early 19th century it was worth a small fortune.

After Christian and his older brother Raymond, who had been born in 1899, the Dior's had three more children, Jacqueline, born 1909, Bernard, born 1910 and finally Ginette, who came to be known as Catherine, born in 1917. Christian shared more physical similarities with Catherine than any of his other siblings, including fine bone structure, an almond-shaped face and bright observant eyes. The two of them also shared other interests and became extremely close – Christian was said to be devoted to her – which would stand them in good stead for the difficulties they would both face in later years.

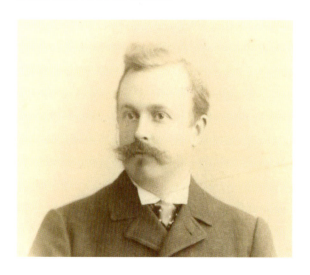 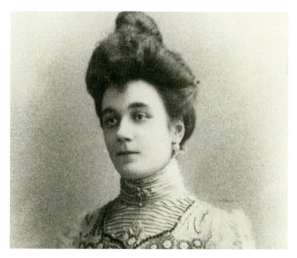

ABOVE: Christian's parents

AN UNEASY CHILDHOOD

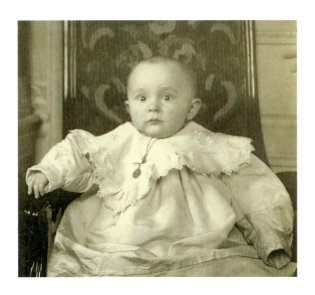 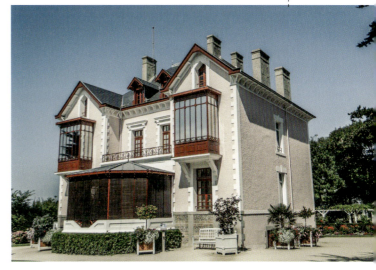

Home to them all was a hilltop villa called Les Rhumbs which overlooked the sea. Their mother Madeleine was a keen gardener who adored flowers, and transformed the windswept land surrounding Les Rhumbs, by establishing an English-style garden which was much admired.

As he grew older Christian was drawn into his mother's passion for flowers and would not move from her side as she planned her gardens. He would wait excitedly for the postman each day to see if new deliveries might bring fresh horticultural joys so that he could put his inherited green thumb to use. Unfortunately, and despite the windbreaks, the location of the house meant that it was constantly assaulted by Atlantic winds. These same winds would also, and often, blow the odour of fertiliser from Maurice's factory into the town, inadvertently creating the very first Dior 'fragrance'; "It smells of Dior today" the townsfolk would say as they wrinkled their noses.

By common consent amongst the siblings, Christian was his mother's favourite, particularly after he had mastered the names of her plants. For the young Christian, the family's large villa was a place of wonder and contentment, and he loved to watch nature's changing presence over the ocean waves.

Inside the villa, partitions of bamboo and Japanese screens with birds, beads and butterflies held his attention for hours on end. The home was tailor-made for a budding creative mind, with glass cabinets containing porcelain and Murano glass in the shapes of shepherdesses or duchesses among the exotic hand-held fans, and the ceiling sculptures that were beset with shadows thrown by the light of the glass lamps. Best of all, however, on those blustery winter nights, was the linen room, where the chambermaids would hum whilst they sewed, and the flickering lamps sent shadows dancing across the walls.

ABOVE: Christian as a baby & the family home in Granville

Christian's young imagination was also fired by the books that he read in those atmospheric rooms. Fairy tales, or the adventure playgrounds conjured up by Jules Verne, were perfect worlds where Christian's vivid thoughts could roam.

Outside, on the streets of Granville, Christian loved carnival time when the town would come alive again, bursting with flowers and costumes. The annual parade, the music and masked balls brought a glorious explosion of worlds and colours to Christian's excited senses. Most thrilling of all though were the costumes. As he grew older Christian's creativity was given a free hand at carnival time, as his siblings looked to him to provide the ideas and the designs for their costumes. He soon outgrew the Harlequins and fairy-tale characters and began to produce more adventurous creations. He became so successful that he was allowed to set up a workroom in the house, where, together with Juliette the seamstress, he would sit and sketch out his designs. He far preferred that to the rumbustious games his school friends enjoyed.

Christmas was another favourite season and brought a visit to his grandparents in Paris. Bathed in the vibrant electric lights of the city, and treated to a cinema trip where Jules Verne's stories would come to life, Christian could dive into his fantasies to his heart's content.

But in 1911, when Christian was six, his idyllic seaside life was interrupted. His father Maurice decided

Delightful Granville

Christian's birthplace, the seaside town of Granville on the Normandy coast of northern France, was a favourite summertime bathing station for Parisians during the late 18th century.

As the 19th century dawned, the town expanded substantially to offer such delights as a Regatta Society, a horse-racing course, a theatre, a casino, an all-important railway station and, by 1912, a golf course, for the entertainment and relaxation of its visitors, who included the literary greats Victor Hugo and Stendhal.

But the town would close for the season in September, and by January the locals, including the Dior family, could parade in peace along the wide esplanade beside the five-mile stretch of beach, bordered by the sea on one side and the cliffs on the other.

In later years, when Christian was established as a fashion designer extraordinaire, every one of his collections included at least one coat named after Granville.

AN UNEASY CHILDHOOD

to upend his family by moving them to Paris, keeping the Les Rhumbs villa for holidays and family gatherings.

From then on, the 16th Arrondissement, Rue Albéric–Magnard, was home to the Dior family. Madeleine set about refurbishing the fashionable home with fervent zeal. Determined to make her entry into Parisian society, money was no object as the house was completely modernised and transformed into a cosy, attractive retreat.

Christian was catapulted into life amongst the latest interior designs with damask wallpaper and lacquered mouldings. Dinners were served by white-gloved servants, a telephone was installed, and the place was full of flowers from the best florists.

The one place Christian dare not roam was his father's study, and in fact he would only enter the dimly lit, fear-inducing room when punishments or admonishments were due from his mild-mannered, though strictly upright father. As far as possible Christian opted out of the cut and thrust of growing up with his father's authority, leaving the conflicts to Raymond, who was obviously going to take over the family business anyway.

Christian showed respectful deference to his father, having been brought up to be well-behaved. He would recall his early middle-class life as one in which his parents discussed nothing 'in front of the children'. He said that consequently he entered adulthood 'totally incapable of finding my own way in life'.

Without a doubt, he preferred the sophisticated life of a Parisian to the world of his father's business which involved ships bearing cargoes of guano from South America, the warehouses and offices that supported the various enterprises, and the factories that terrified him. With his tastes formed and refined by Madeleine, Christian determined never to work anywhere bearing even a slight resemblance to an office.

Largely left to his own devices as a child, Christian could indulge his fantasy without too much interruption. The solitary boy would produce the solitary man, a dreamer with a love of nature and flowers, a love that would remain

AN UNEASY CHILDHOOD

with him throughout his life. Solitary, however, did not mean sad; on the contrary, he was affectionate, lively, and curious about the world in which he lived. Tomboy Jacqueline, tough Raymond and over-sensitive, introverted Bernard were very different from Christian and his soaring imagination.

Also living with the family in Paris was his maternal grandmother Juliette Martin, a woman with a strong conservative character. She came to live with the Dior family during the economic turbulence that 1918 ushered in, which diminished her own finances. Though the rest of the family thought her a chatterbox, and she was decidedly opinionated, Christian delighted in her presence, and he was more than happy with the arrangement.

She became the person to whom he could unburden himself, who would talk to him of the star-filled heavens, of foreign lands and ancient civilisations, introduce him to the intriguing world of fortune-telling and other worlds beyond that framed by his vision. It was to her that Christian would turn for approval of his costume designs.

Outside the home, Christian spent many hours playing in the Bois de Boulogne Park, west of the city, until starting school at the Lycée Gerson. He recalled these early years as an era that provided 'a happy, jaunty, peaceful time when all we thought about was enjoying life. We were carefree in the belief that no harm threatened the wealth and lifestyle of the rich... the future would bring nothing but even greater benefits for all... nothing can rival my memories of those sweet years'.

However, those 'sweet years' were about to be cruelly truncated as World War I descended upon rich and poor alike, shattering the tranquillity of Belle Époque France and bringing unexpected shocks into Christian's existence.

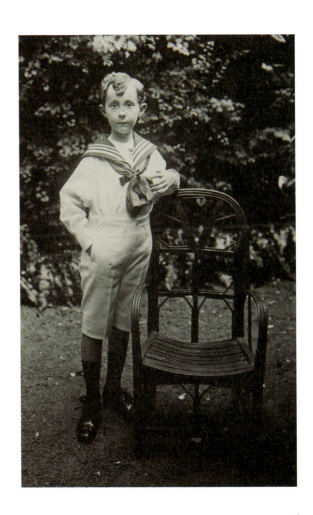

ABOVE: Christian Dior as a young boy

PARADISE LOST & FOUND 1914-1920

"I think that we have to be aware that people are allowed to make mistakes in their life."

As the Germans swept west towards Paris in August 1914, the roads of Eastern France became choked with refugees fleeing the area. Christian's parents decided that it would be best to return to Granville, Normandy, far from the conflict zones, and await developments. Paris became a distant memory, the bright lights vanished into history, and Christian would spend the next four years, when he was aged from 9 to 13, in Granville, where the Hôtel Normandie and the casino were now filled with beds for injured soldiers.

The Dior family was not one to remain inactive; they worked to provide parcels for the prisoners of war of the French and entertainment for the soldiers. Christian would later note that despite the atrocities that were destroying human existence, the ladies of Granville were anxious not to let their fashions fall behind and were quick to order the latest Parisian styles. Christian's life fell into a pleasantly gentle interlude. It was carefree; for this period was left unscrutinised in his autobiography many years later. Perhaps his silence stemmed from guilt about the quiet life he enjoyed while his elder brother, Raymond, took action and enlisted as a volunteer in 1917. Raymond narrowly escaped death but was traumatised for the rest of his life by events on the front line that saw his entire platoon wiped out by artillery shells, leaving him the sole survivor. However, given that Christian was so young he really had nothing to feel guilty about.

When the war ended in 1918, the world had changed and so had Christian. Now a teenager in high school, he was anxious to return to the fast-moving life he had left behind in Paris. He had, to the casual eye, become a boy of languid movement, calm and polite, whilst his interior life bubbled with yearning for a life of

colour and excitement. Christian Dior was an aesthete, he loved beauty and wished to avoid life's ugly protuberances, preferring to turn his attention to the good things in life.

Paris, too, was anxious to leave the terrors and greyness of the war years behind, and life became vibrant again with cabarets open until the early hours, festivities, and celebrations of life on the Place de la Concorde, at the Châtelet Theatre, the jazz clubs, and other places of entertainment. This was the Paris of the Ballet Russe, of Picasso and Matisse, of Paris entering Les Années Folles, the crazy years.

Fortunately for Christian, Maurice's business was doing better than ever. So Maurice took his family – now expanded to include Ginette - together with the children's much-loved governess, Mademoiselle Marthe, back to Paris. Their new home was 9 Rue Louis-David, where they had a large apartment, which was redecorated by Madeleine with furnishings and colours that were appropriate for a family firmly, and very comfortably, established in middle-class Parisian society.

Christian still assisted his mother but had now passed from being a silent partner to one who would make his own suggestions, helping to

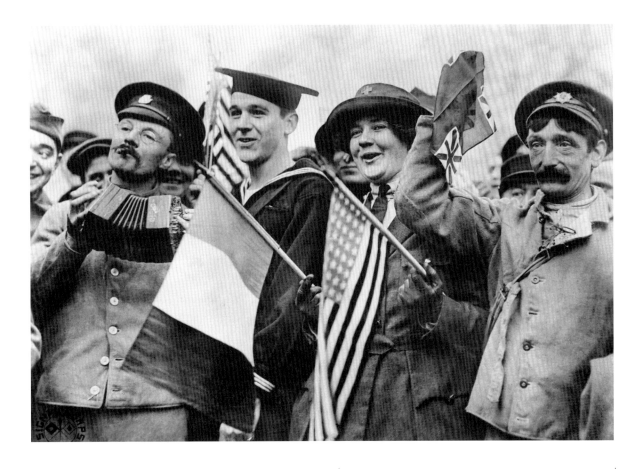

ABOVE: An American sailor in the crowd on the Place de la Concorde on Armistice Day, November 11, 1918

decide on flower arrangements and menu plans. This degree of closeness to his mother, slight as it was, earned him the envy of his siblings. His perseverance with Madeleine also brought him an invitation that would prove significant to his destiny when he accompanied her on a visit to her dressmaker Rosine Perault. None of his siblings were interested in clothes, especially Jacqueline, who would often wear outfits of which Christian, even at that young age, strongly disapproved.

Now back at school at the Lycée Gerson, Christian had found two friends who were on his same wavelength, anxious to be swept along on the wave of modernity. They often accompanied Christian as he set about exploring this fascinating new world that was opening before his eyes, a Paris that offered pathways to anywhere, should anyone care to wander down them. And Christian certainly did wish to wander down the paths that led to the less salubrious areas of town and participate in all the 'truly novel novelties it had to offer'.

While this was hardly the life that his parents envisaged for him, it was most definitely in keeping with his creative contemporaries, who were also sounding out their artistic natures, and carving out spaces in which their unconventional personalities might breathe more freely.

Christian had quickly discovered that he was astride two conflicting existences. On the one side were his parents, wedged into the prejudices and narrow-minded intolerance of their age and restricted by the conventions of their class, and on the other, the world of creative artistic endeavour that rebelled against such artificial parameters. The shy Christian with his childlike awkwardness, successfully managed to negotiate a peaceful route between these two opposed outlooks on life. His outward-facing imperturbability was a useful cover for his other life, which unfolded when he escaped parental surveillance to inhabit the downtown bars, such as the favoured Le Boeuf sur le Toit, where the avant-garde assembled en masse. Christian joined the other unknowns to watch this outburst of life from composers Erik Satie and Francis Poulenc, the poet Louis Aragon, and artists Pablo Picasso and Jean Cocteau.

The sound of traditions smashing came from the studios of composers Stravinsky and Schoenberg, the cubist painters, and the surrealists. New influences were charging through the barriers in the theatrical world, too.

Described at this time as having thin hair atop an oval face with a slightly receding chin, Christian spent hours drinking cocktails in bars with his friends, soaking up the animated and thought-provoking discussions around them.

PARADISE LOST AND FOUND 17

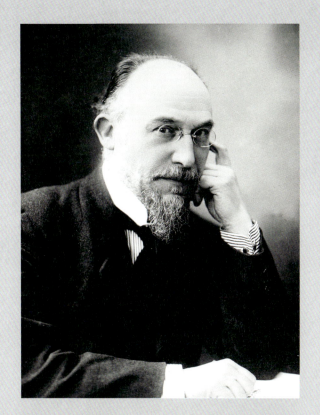

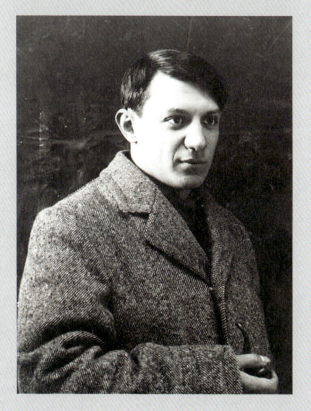

ABOVE CLOCKWISE FROM TOP LEFT: Erik Satie, Francis Poulenc, Pablo Picasso & Louis Aragon

LIFE ON THE EDGE 1920

"From his very first works, it was clear that Henri Sauguet would bring spontaneity, romance, and a non-academic approach back to modern music."

Having successfully balanced his studies with his exploration of Parisian creativity, Christian emerged from his school years with his diploma and turned his thoughts to his future career. It was obvious that some kind of creative endeavour would snag him, but what? He had no desire to be restricted in any way either personally or professionally.

He was drawn towards architecture and passionate about art, also about design and decoration, houses, and their gardens. Struck by the words of author André Gide, who advocated overcoming the restraints of an austere childhood to enter a world without preconceived ideas or preconceived ambitions, Christian looked with interest towards the Academie des Beaux-Arts.

Until then completely unaware of these artistic ambitions, his parents came down on his head like the proverbial ton of bricks when they heard of his plans. An academy of fine art was hardly

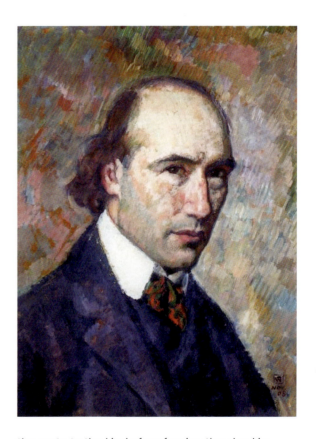

the route to the kind of profession they had in mind for their son. The embarrassing awfulness of a bohemian in the family was almost too ghastly to contemplate and to them meant only poverty, misery, and destruction. In their opinion a company director was a more suitable profession.

ABOVE: Portrait of Andre Gide

With both his parents refusing to give ground, Christian caved in. But, silently resenting them, he was seized with uncharacteristic rage: 'I used to have frequent arguments with my father, which ended in doors slamming and the ultimate expletive: Filthy bourgeois!' he said later.

Although he had appeared to acquiesce, inwardly he was still on the same path, and, employing the same methods of subterfuge he had used to keep his nightlife under wraps, he enrolled at the Faculty of Political Sciences on the Rue Saint-Guillaume.

Believing that their son had seen the light and would go on to become a diplomat, Christian's parents did not realise that the faculty was far more liberal than they imagined, as there were no commitments. Lectures were given on interesting topics, so that the school might just as easily turn out a photographer as someone interested in politics. Christian could pick up his cocktails and indulge in pastries again and carry on as before. With his parents happily in the dark, he gained time to enjoy, as he put it, 'the greatest freedom possible... allowing me to lead the life I liked'.

For Christian this meant diving into the cultural milieu in Paris and befriending the artists and creatives of the time. He greatly admired the work of Jean Cocteau for example, whose visually daring and inventive ballets scandalised Paris society, but riveted young Christian.

Breaking out

During the 1920s Christian was still coming to terms with acknowledging his homosexuality.

His sexual inclinations and other pastimes were necessarily hampered in their expression by his life in his parent's house, and unlike some of his friends, breaking out of the mould was not so easy for him.

Because homosexuality was not illegal in Paris as it was elsewhere in Europe and the world, those who were homosexual came from all over to enrich the French capital with a creative spirit and wild, sartorial abandon.

While Christian Dior watched, listened, absorbed, and participated, his own journey had not yet begun; but when it did, it would emerge from the extraordinary seedbed that had been those interwar years when life seemed endless and the future was there to be 'wooed and won', as Winston Churchill, Minister of Munitions at war's end had described.

All of Christian's senses were awakened by new music, new art, new theatre, new writing. Hoping to become part of this world rather than an onlooker, he even composed music of his own and met with Henri Sauguet, a composer he greatly admired. Christian was said to have been magnetised by the 'lively eyes, sparkling with mischief … incredibly mobile features, the wit and intelligence' of his conversation with the composer.

His parents would have been utterly horrified by what they would have considered to be a descent into debauchery.

But Christian adored his new lifestyle as he was drawn into the centre of this artistic whirlwind, where he had found a group of friends who would accompany him throughout his life. He became immersed in this world of painters, poets, actors, and writers. He particularly admired the paintings of Christian Bérard and even managed to seduce his father into buying one. He also had the painter's sketches plastered onto his bedroom walls.

In between the fun and laughter, the friends would debate literature and art, chat and gossip and discuss theatre and music. Henri Sauguet described those times as such fun; 'What discussions, what ideas… there was so much to tell, to experience, to voice an opinion on". The group donned clothing that would shock their parents' generation, dressing like dandies or in paint-splattered trousers or bowler hats, often pairing their sartorial choices with some affected speech patterns. They mocked the genteel establishment, with Cocteau and painter-poet Max Jacob particularly vocal on that score. Christian threw himself wholeheartedly into the fun and games.

Looking to London for his British-influenced style, Christian was never so enthusiastic as when required to dress his fellow funsters and pranksters during their sessions of masquerades. In one of these he met Jacques Bonjean, who became a significant feature in his life.

Always in his element when dressing both himself and others, Christian seized every opportunity presented by his friends' parties and pantomimes. It was an extraordinary time for someone of his creativity to be alive in Paris, when wealthy patrons like Count Etienne de Beaumont could turn the snippet of an idea into an opera, or a ballet, or a play.

Paris was the centre of the world, and the world came to Paris, where social mores were upended, and talent could forge new and exciting paths. And Christian Dior was now at the epicentre of this vortex, a frequent visitor to the soirées thrown by Count Etienne and to the many Parisian balls.

RIGHT: Portrait of Count Étienne de Beaumont

THE PARALLEL LIVES OF CHRISTIAN 1921-1930

"It is unforgivable to do what one doesn't love, especially if one succeeds."

As Christian entered his 20s, he was no closer to alighting on his life path than he had ever been. Indeed, even his mother was beginning to realise that his studies, such as they were, at the School of Political Sciences, were not going to lead him to an ambassadorship anywhere. Christian was a bright student, according to his professors, but one who lacked assurance in his oral presentations and could not be bothered to knuckle down to serious work. He missed an entire semester, and the following year, 1928, his greatest contribution to his studies were the words, 'I withdraw'. At 22 years of age, he had already been required to retake his third year, and exams were the devil's work as far as he was concerned, so he rolled out a plethora of excuses for avoiding the final one.

He tentatively suggested to his parents that he might exchange political science for the School of Palaeography and Librarianship; unsurprisingly, the suggestion was strangled at birth. Maurice and Madeleine's worries increased, especially as there was a stark contrast between Raymond – now married - and Christian, who seemed incapable of applying himself in any meaningful way to anything. They eyed with suspicion the friends that he brought home to rehearse in the drawing room, increasingly doubtful that allowing him to study musical composition had been a wise decision.

Experiences amongst the bohème of Paris had changed Christian. But despite his elegant new suits and hats, Christian was not pleased with his appearance, as he didn't consider himself to be physically attractive. Still, he got on like a house on fire with his female friends and was known as a raconteur and jester. Those relationships were made easy for him, as his investment in them was

RIGHT: Christian Dior, Early 1920s

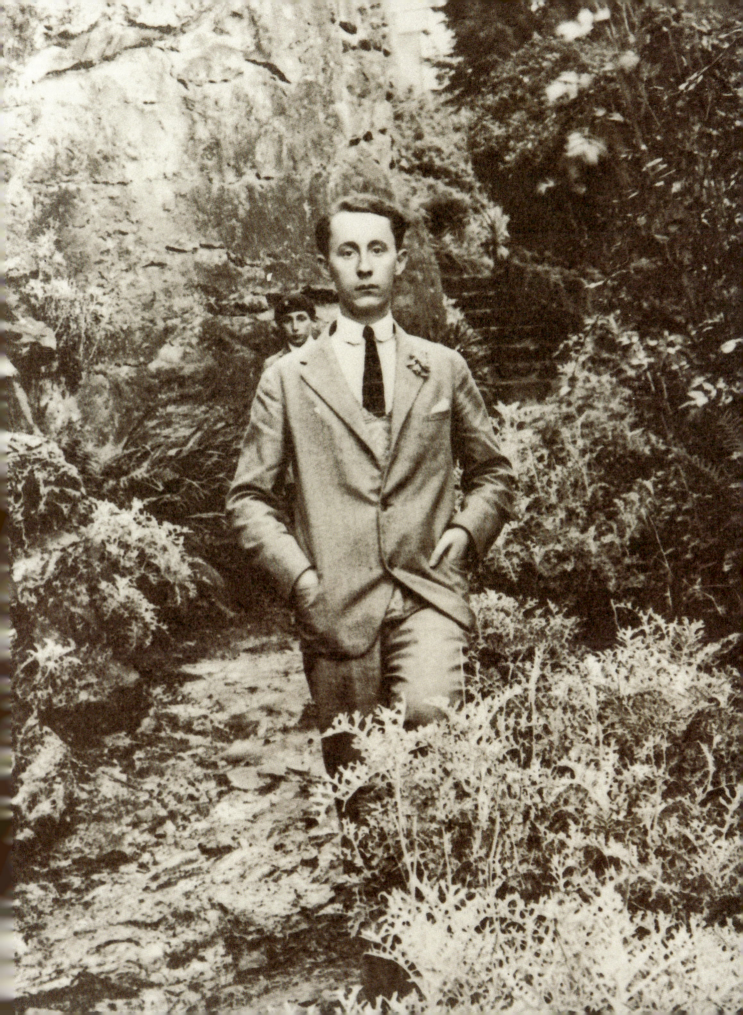

THE FASHION ICONS DIOR

purely social, and he referred to his girlfriends as his pets, often sketching ball gowns for them. His social life was as rich as ever as he formed new friendships; including Nicole Riotteau, the daughter of a ship owner and the heartthrob of all the boys in Granville; and Suzanne Lemoine with whom he formed a particularly close relationship. She was a champion sportswoman playing both golf and tennis, although sport was most definitely not on Christian's list of desirable pastimes. Indeed, he could be said to have been rather slothful. Nonetheless, his summers still consisted of charity fetes, croquet, golf, charades, picnics, and swimming.

And then there was his friend Serge Heftler-Louiche, the handsome young man who turned girls' heads, too. Serge was to surface many years later as the man who would create the Parfums Christian Dior line in 1947.

This was how Christian spent his life, without any tangible ambition to guide him or encourage him to move forward. 'All I required to be happy was friendship and people I could admire', he said of his younger self in his autobiography. It seemed that his talented friends quashed his own timid belief in himself. While he bathed in his friendships with Christian Bérard and Henri Sauguet, his own talent languished, neglected, though seemingly intact, on a bed of uncertainty, shyness, and lack of self-esteem. Neither was it helpful, perhaps, that his father's largesse meant he could enjoy his lifestyle without the bother of having to earn money of his own.

ABOVE: Christian Bérard (L) & Henri Sauguet (R)
RIGHT: Paul Poiret

THE PARALLEL LIVES OF CHRISTIAN

Christian maintained his role as onlooker as the greatest artistic upheavals unfolded before his eyes. He developed great discernment during his exposure to this dynamic mélange encompassing everything from cinematography to gymnastics, poetry and choreography, the visual arts, the musical arts, and the fine arts.

Someone who made a deep impression on Christian at the time was himself a couturier; his name was Paul Poiret, a pioneer in his field, who considered himself not only to be a designer but a decorative artist, a creative. He raised the dress designer into a new league, and he was tireless in drawing together the creative streams of his era, producing his own new ideas, conjuring up new creations and offering encouragement to others. Christian could not but be entranced by this magician of his craft.

His other friends, meanwhile, were going from strength to strength, already working their way into Parisian high society, becoming favourites of the wealthy patrons such as Princess Dolly Radziwill, Daisy Fellowes, or as was the case with Henri Sauguet, Charles and Marie-Laure de Noailles, with whom he would spend summers on the French Riviera.

Christian also received invitations to some of these glamorous gatherings, but his lack of confidence in both his character and appearance hampered his enjoyment. However, his smooth passage between tacit acceptance of his parent's sphere and his preferred bohemian sphere, also allowed him to comfortably inhabit both.

OFF AT A TANGENT 1927-1930

"I was never to let my name appear in the title of the business."

Before facing a decision on his future, Christian had first to complete his required period of conscription in the French army, which began in October 1927. As Sapper, Second Class Dior, 5th Engineers Corps, Christian's duties included lugging railroad tracking around.

However he was fortunate to have his time in the army sweetened by meeting Nicolas Bongard, the nephew of couturier Paul Poiret whom Christian had known in Paris. Bongard was also acquainted with the likes of composer and pianist Erik Satie and artist Pablo Picasso, who had been visitors to his family home when his mother, a poet, had staged exhibitions there during the war.

Conscription done, and with his time in education behind him, Christian still needed to decide his future. Still unsure about how best to exploit his talents, whatever they might be, his first idea was to open an art gallery, which would keep him in contact with the bohemian and artistic circles in which he was now thoroughly at home. He knew, however, that his decision would seem, 'the greatest folly of all' to his parents.

GALERIE JACQUES BONJEAN

BÉRARD, BRAQUE, E. BERMAN,
L. BERMAN, CHIRICO, DUFY, HALICKA,
LAURENCIN, LÉGER, LURÇAT, MARCOUSSIS
MAX JACOB, PICASSO, TCHELITCHEV, ETC...

du 3 au 23 Mai : MAX JACOB
du 24 Mai au 12 Juin : Les DUFY
de la Collection PAUL POIRET
du 14 au 30 Juin : Dessins de BÉRARD

34, Rue La Boétie (au fond de l'Impasse) Élysées 57-20

The decision to become the director of an art gallery was prompted by his friend, art enthusiast Jacques Bonjean who was searching for a new partner for his own venture, having previously had problems with two other potential partners – French-Jewish writer Maurice Sachs and Gaspard Blu who was a protégé of the poet Max Jacob.

Undaunted by the fact that Sachs and Blu had thrown in the towel, Christian was enamoured of the idea; but felt that his parents would surely view this latest enterprise as yet another aberration. However, to his surprise, they were not averse to the idea, perhaps grateful that their son was at last heading for a profession – of sorts. As a result, his father made the

necessary investment of 100,000 francs available, and Christian and Jacques set up their enterprise at 34 Rue la Boétie.

Christian's mother's one condition was that her son's name should not appear above the gallery. She saw little difference between an art gallery and a grocery shop; both reeked of trade, and the shame involved in being connected with either would have been insupportable to her. Christian was seemingly indifferent to her wish at the time, although his actual unease surfaced after Madeleine's death.

Christian's parents may not have been so enthusiastic had they realised that the attitude of their son and his partner towards the gallery was to regard it as a branch HQ for their circle of friends, with just a dash of attention to business. Jacques and Christian shared a love of humour, and Christian also found an outlet for his musical skills in Jacques's wife Germaine, with whom he would play duets. Later, he was godfather to Jacques and

ABOVE: Gallery Jacques Bonjean at 34 Rue la Boétie

Germaine's daughter, Geneviève Page, who became a well-known actress.

Things got off to a good start when artist Max Jacob promised them that they could sell his gouache paintings, but hopes were dashed when it was discovered that Max had, in fact, contracted to give them to someone else. This sobering liaison helped them realise that they would have to pay more attention to their business if it were to succeed. They then managed to persuade Christian Bérard to come on board, which was quite a coup, because his name was almost a guarantee for success. And so it proved. Christian Dior was quite adept at talking to clients, being very used to those wealthy art lovers whose patronage enabled his artistic friends to flourish, and he could win people over quite effortlessly. Jacques, on the other hand, confessed to his own awkwardness in such situations.

Those years of hope and the promise of a bright future were standing on a precipice. There were storm clouds on the horizon during that summer of 1928, though few could, or wished to, acknowledge them.

For Christian Dior, there was more emotional turmoil waiting to pounce and defile his good fortune in a shorter period than he could ever have imagined.

Neo-romantics

The gallery Christian and Jacques established successfully rode the wave of the maturing youthful artists of the early 1920s, who were producing brooding, often nostalgic, work labelled neo-romantic . The movement was a reaction against the cubists, dadaists and surrealists, representing a return to elegance and spontaneity, looking inwards at emotional life.

With visions of sitting on a gold mine, Christian and Jacques were canny enough to make the most out of the clash between those who believed that the new was simply retrograde, and others considered truly modern, including Picasso and Dalí. And they were fortunate in that author and art collector Gertrude Stein was a loyal customer to the gallery, which was becoming something of a happening local venue with a growing reputation as the place to be seen. This was not least because some art critics approved of these new iconoclasts storming the art-world barriers, such as Otto Dix, Paul Klee, Salvador Dalí, Max Ernst and Alberto Giacometti. Christian and Jacques were careful not to alienate the more 'mature' tastes amongst their clientele and also exhibited established artists such as George Braque.

OFF AT A TANGENT

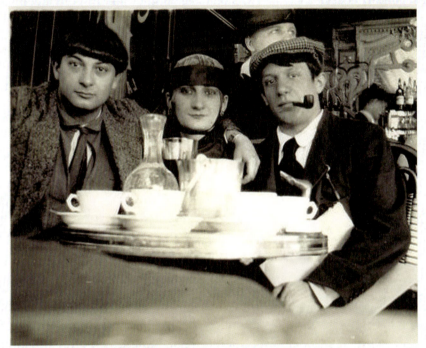
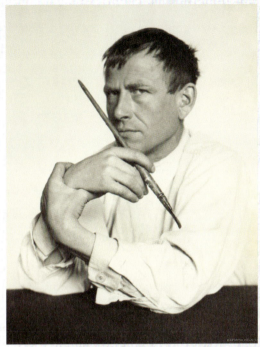
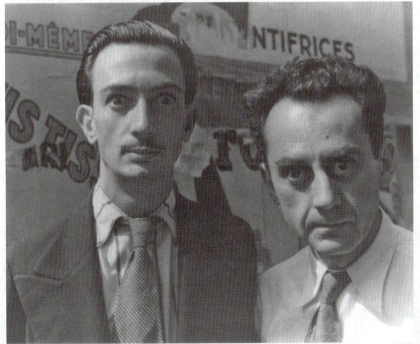

ABOVE CLOCKWISE FROM TOP LEFT: Moïse Kisling, Paquerette and Pablo Picasso at café La Rotonde, 105 Boulevard du Montparnasse, Paris, August 1916; Otto Dix, 1929; Paul Klee, 1922; Salvador Dali and Man Ray, Paris, 1934

A FAMILY IN TURMOIL 1928-1932

"We went from losses to goods seized by creditors, while continuing to organise surrealist or abstract exhibitions…"

While Paris still revelled in its status as the revived centre of the creative and cultural world, a seismic shock had occurred across the Atlantic, where the financial institutions of the USA were in big trouble, dragging stocks, shares, savings and untold wealth with them. This would go on to suck the wealth of people everywhere in the world including in Germany, where it cleared the way for destitution, suicide, and Nazism.

But initially France was not yet caught up in the financial riptide that engulfed America. In fact Maurice Dior basked in the success of his enterprises and their booming financial rewards. His business had done phenomenally well, going public in 1923 when he took a share of the capital. As time went on, he withdrew from the daily ebb and flow of running his company, leaving that to his cousin, Lucien.

Maurice decided to focus on building luxury apartments on some land that he had bought in 1916, which was now worth a small fortune. He foresaw rental income that would secure the financial future for his children. Financing for the new project would come from the sale of his share portfolio. Even after the Wall Street Crash of October 1929 reduced the value of his stock by 20 per cent in just a few days, Maurice calculated that this was part of the swings and roundabouts of the stock exchange and concluded that the winds would change in his favour.

To continue with his enterprise, he took out a loan for 9.5million francs, envisaging that within two years, once the apartments were built, his financial affairs would straighten themselves out again. The Dior family continued living the life to which it was accustomed. But then, in 1931, the first of two mortal wounds was inflicted.

First, Bernard, at 21, the youngest son of the Dior family, was descending into insanity. He had become so unstable, even dangerous, that there was nothing for it other than to send him to a psychiatric institution. The family chose one at Pontorson in Normandy. Bernard, that 'fine young boy' with such sweet angelic looks, would never

leave its walls again, and would die there almost 30 years later, at the age of 50.

Whilst Bernard's condition and incarceration was a shock for the whole family, for his mother, Madeleine, it shattered her very being. Always strictly adhering to the self-imposed bourgeois regulation that forbade shows of emotion in public, Madeleine internalised her pain, consequently becoming ill with a benign tumour. She was admitted to hospital for an operation to remove it, but died a month later from septicaemia, aged just 51. Her last resting place was in Granville; her funeral a quiet occasion as befitted her outlook on life.

'My mother', wrote Christian in his memoirs, 'whom I adored, secretly wasted away and died of grief'. Her death, he said, marked him for life. Gone were the times they had shared as they planned the garden in Normandy and furnishings for the house in Paris; the tussle between them about his artistic inclinations and his life choices now forgotten. The absence of the woman he adored left a hole in his life that could never be filled, and from then on he placed her memory on a pedestal, raising her to a status to which other women could never reach.

Madeleine's death heralded more catastrophic news for the family.

The ripples from the Wall Street Crash were now large enough to topple Maurice Dior. The construction of his apartments had been delayed and the property market had fallen in value. The loan on Maurice's property was called in and his shares in the family firm, Dior Frères, were now not worth the paper they were written on; Maurice went bankrupt.

Each member of the Dior family was confronted with the wreckage of their family life and coped in their own way. Christian had the presence of mind to take some of the valuable objects, furniture, and paintings, from the Paris apartment before the bailiffs arrived, an act of cool-headed practicability, which, as his partner Jacques pointed out, no one would have expected from the rather spoiled young aesthete.

His elder brother Raymond, who also hovered on the edge of mental equilibrium, was saved from his own suicidal tendencies, by the lifelong care, patience, and good-natured strength of his own wife, also called Madeline. Bernard was oblivious to it all of course, ensconced within the walls of his institution, while Catherine would soon help the regrouped family to survive in the south of France by growing green beans and peas.

Maurice, bereft of his beloved wife and with everything he had achieved reduced to confusion and memory, left Paris to stay with his brother Henri.

Fate, however, had one more bitter blow in store for Christian as he gingerly tapped his way unwittingly towards fame, and into the dangerous decade of the 1930s.

ONE STEP DOWN, ONE STEP UP 1932-1939

"All I required to be happy was friendship and people I could admire."

Christian's immediate reaction to his domestic crises was to escape by taking a trip to revolutionary Russia. He was lured by the thought of visiting the homeland of such cultural icons as Prokofiev, Stravinsky, Chagall, and, of course, Diaghilev and the incomparable Nijinsky.

On arrival he found his romantic notions of the nation challenged by the reality of crumbling facades, empty shops, unbearable poverty, and dilapidated palaces. 'Nothing could alter my impression that Russia under the Tsars enjoyed a better way of life than this' he recorded afterwards.

Returning via the Black Sea and Constantinople, he finally arrived back in Paris to face a very altered family situation. No sooner had he arrived than he was confronted with another fissure opening between the bitter present and his gentle past. His partner Jacques had now been swept up in the aftermath of the Great Depression and was ruined.

Christian joined Jacques in moving the remaining artworks to another gallery run by Pierre Colle but alienated potential buyers by attempting to sell abstract and surrealist paintings. Making a living became even more difficult because there were practically no foreign buyers left in Paris, all the expatriates having turned for home. Debts could not be serviced when prices for paintings were falling so rapidly, sometimes selling for just a quarter of their true value.

During 1932, after the apartment in Paris had been seized to repay debts, the Dior family had gone back to live in Granville. So Christian was forced to accept the charity of friends, who now repaid his previous kindnesses to them with their own generosity. Now 27 years old, Christian felt strangely refreshed by this enforced freedom from belongings. His fate was common to so many in his generation, living in an era which exonerated individuals from personal fault. Such uncertainty seemed to present even more reasons to continue a bohemian, carefree lifestyle, which is what

'I discovered a new desire to create something of my own'
CHRISTIAN DIOR

Christian and his friends did, often assisted with free food by the patrons of the establishments they had long frequented.

Then Pierre Colle's gallery was forced to close, leaving Christian Dior penniless. As if that wasn't bad enough, he then contracted tuberculosis. His illness confirmed the closeness of his group of friends who now collected funds for his treatment, sending him to the Pyrenees to stay in a sanatorium and then to Ibiza to recover in the warmth.

Time seemed to stand still for him. 'I discovered a new desire to create something of my own', Christian wrote later. Without the distractions of Paris, he focused on a new passion - the tapestry weaving of local craftspeople. He threw himself into this new interest, drawing his own designs and making use of his talents with a needle, which he hadn't done since making costumes for his friends' dressing-up parties as a child.

Intuitively, Christian understood that he had found a pathway to his future. Although his attempts to open a workshop on the island failed through lack of funding, his Spanish voyage of self-discovery eventually led him in the direction that would allow his talent to flourish.

Christian returned to Paris to find his father's situation worse than before; the family was now in financial dire straits. Maurice was no longer mentally strong enough to avoid total impoverishment, and homelessness was only avoided when the family's former governess, Marthe, offered the family refuge in her own home in the town of Callian in Provence, southern France. Marthe showed touching care for her former employer.

It was left to Christian in Paris to try and find gainful employment in the city, which was itself now crushed beneath the weight of the Great Depression. The task was dispiriting, as most companies were shutting and shedding employees, and his entreaties were rejected by all the offices he visited. It was only the loving attention of his friends that prevented his spirit and motivation from collapsing entirely.

It was while pounding the Parisian streets in the fruitless search for employment that he was rejected for an office job by the couturier Lucien Lelong. This interaction with a fashion house made Christian suddenly realise that he would be better suited as a couturier than anything else. Remembering the costumes he had sewn in the past, and deciding to pursue this new direction, his luck began to change. A little

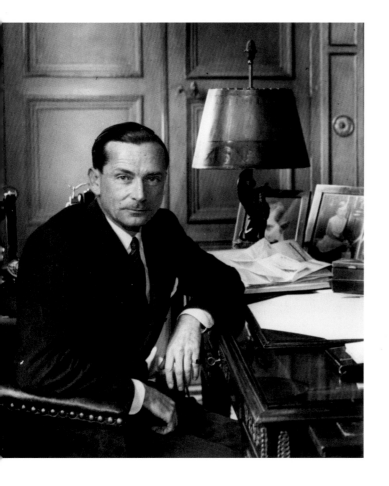

a draughtsman, selling sketches to fashion houses. Christian needed no prompting, and burning with motivation, absorbed the illustrations in the magazines, whilst being taught how to hold a brush and discussing the use of colours with Max Kenna, Jean's American companion. Christian realised that he had never learned even to hold a pencil correctly as an artist. But he drew and sketched like a man possessed until he had mastered his tools. With the focused passion that he had found for weaving on Ibiza, Christian immersed himself in his new profession.

His hard work was rewarded, when Jean sold six of Christian's sketches for 120 francs one day. Those 120 francs, said Christian, 'were to decide my future. And I can still see them gleaming!'

money came his way when he sold a painting by Raoul Dufy, *Plan de Paris*, and he used this windfall to help his family in their own distress, as well as to strengthen his resolve to pursue his newfound plan of action.

That piece of good fortune was followed by another, when Jean Ozenne, the cousin of his friend Christian Bérard, came to him with a proposal. Having witnessed Christian conjuring costumes from whatever he could lay his hands on, Jean thought that Christian would be ideal to help him in his own enterprise as

Now aged 30, and once more in control of his destiny, Christian hurried down to the south of France to be with his family again and hone his newfound skills.

In Provence, he continued his feverish work rate, astonishing his father with his dedication. Two months later he decided it was time to put his skills to the test and returned to Paris where a meeting with the chief editor of *Vogue*, who offered encouraging and honest criticism, inspired Christian to work with renewed energy in the knowledge that he was close to success.

ABOVE: Lucien Lelong
ABOVE RIGHT: 1935 design by Robert Piguet

And indeed he was. Although his hats initially proved more successful than the gowns he designed, he kept going, continuing to work and learn furiously, until gradually, the big names could be added to his list of clients, including Schiaparelli, Balenciaga, and Rose Valois. It was 1935, and 50 clients made use of his talents, attracted by the energetic movement and expressiveness in the sketches.

With his newfound financial stability, Christian moved out of the Hôtel de Bourgogne, where he had lived since 1936, and rented his own apartment at 10 Rue Royal. Its five rooms cost 8000 francs a year.

The two Christians, Dior and Bérard, scoured flea markets and second hand shops in Paris to decorate the new apartment with chintz, vases, Spanish shawls to throw over sofas and upholstered armchairs. All very bourgeois. All very comforting reminders of a safe past. Christian even engaged his own chef. But he still ensured a flow of funds to his family in southern France.

Another exciting development came when Christian was introduced to the celebrated couturier Robert Piguet. Spotting the talent shining from Christian's sketches, Piguet asked him to design some dresses for a collection. Piguet was keen to develop Christian's own style,

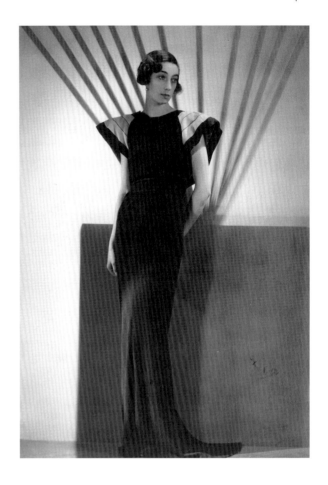

and Christian wasted no time in grabbing the bull by the horns and launching fearlessly into his own imagination. Christian Dior was now a name to be sought after, as fashion houses clamoured for his designs. Rejected no more, Christian was his own master, and both *Vogue* and *Le Figaro* used him as a correspondent.

Christian was so successful that in 1938 Piguet employed him as a modéliste to design Piguet's own creations. It was not an easy position, working under the whimsical and severe couturier, but it provided Christian with invaluable experience

and introduced him to the world of 'premières, vendeuses and ateliers', as he delved into the mysteries of 'biases and pocket reinforcement'.

Café Anglais was a dress with a short, full skirt that Christian designed for his very first collection, a houndstooth dress with petticoat edging, which opened even more doors for the young illustrator. One of these 'doors' brought an introduction to the editor in chief of *Harper's Bazaar*, Carmel Snow.

As his bohemian friends also began to climb the ladder of success, so they engaged Christian's services, and his creations began to appear on stage to applause from the audiences. One such production was A School for Scandal, for which Christian, '... maniacal in his detail, giving extremely precise instructions and leaving no room for interpretation', produced exaggeratedly large hats and employed bright use of colour, eliciting enthusiastic comments from all those who saw them.

Christian's life had blossomed beyond recognition in just a few years, and even his private life, about which he was so obsessively secretive, was now shared with a tall and slender man 10 years his junior by the name of Jacques Homberg. His financial affairs secured, he used some of his hard-earned money to travel with his new companion and visit the antique shops, museums and countryside of Europe.

However, once again, disturbing events were taking place just across the border in Germany; Adolf Hitler had been in power since 1933 but having largely ignored his increasing aggression towards his neighbours initially, European countries were now becoming uneasy.

'Fearing the inevitable cataclysm, we were determined to go down in a burst of splendour', said Christian in his memoir, and in the late 1930s the pleasures of bohemian life in Paris, 'had rarely seemed more scintillating'. As bright young people flitted 'from ball to ball', designers and artists from Picasso to Coco Chanel or Christian Bérard were engaged by high society to arrange the decor for their gatherings. Others such as composer Erik Satie and dancer Serge Lifar produced works to astonish, delight and plunge Paris into an oblivion of hedonism once more.

Perhaps the greatest of these events took place in the Hôtel Salé, reopened for one night only for 500 guests, bursting to the rafters with roses and lilies of the valley, bustling with the very best that high society had to offer; including the Duchess of Windsor. And Christian Dior.

Then, in September 1939, church bells rang out in France. Everyone knew it meant war. It was time to defend the cultural inheritance of all European nations.

RIGHT: Robert Piguet with Christian Dior, circa 1937

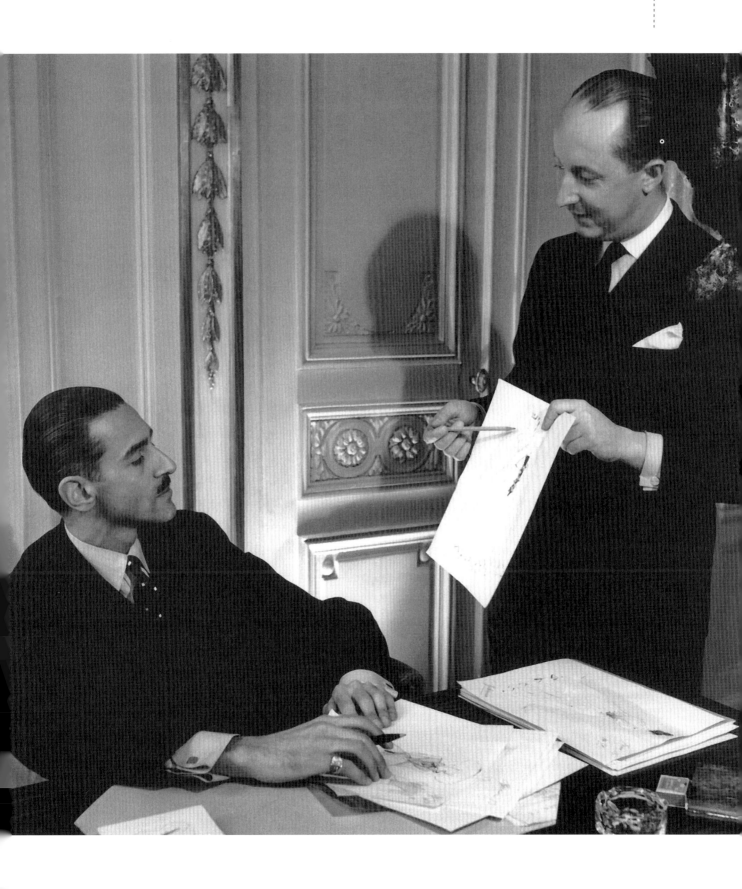

DARKNESS DESCENDS 1939-1945

"I'm a mild man, but I have violent tastes."

Christian Dior became a French army officer until, in May 1940, Hitler's armies raced through northern France. Within six weeks the country had capitulated and was now in two halves, with the Germans occupying the north and Marshal Pétain entrusted with keeping order, in accordance with instructions from his Nazi superiors, in the south.

Upon being demobbed and given 800 francs, Christian decided not to return to Paris immediately. Instead he spent some time in the countryside he adored, experiencing the 'cycle of the seasons', where he could indulge his love of flowers and plants; thus he stayed a year in the little village of Mehun-sur-Yèvre.

Then, instead of returning to occupied Paris, he instead, travelled to be with his family again under the blue skies of Provence. There, Christian and his sister Catherine planted vegetables, hoping to sell them at the local markets. US $1,000 from the sale of a painting in America helped tide them over in the meantime.

And then the name of Dior was sought once again, by the fashion world.

Le Figaro's women's page editor, Alice Chavane, was looking for someone to provide sketches of the top designers' dresses. So, working at night by candlelight because there was no electricity in the house, Christian set to work once more, after he had finished his day's work on the land. Back in Cannes, Alice was absolutely delighted with his final sketches, that were, according to her, equally as good as the top couturiers.

In mid-1941, Christian received a message from Robert Piguet; the fashion houses were opening for business once more and did Christian want to work for him again? Although many big names had abandoned Paris, and indeed France, the fashion industry was in no mood to relinquish its grip and allow the torch to pass to America. But in fact, Christian was not particularly keen to go to Paris and so delayed his trip there by several months.

RIGHT: Marshal Pétain

On his eventual arrival (wearing the look of an English dandy, replete with brogues and a jay feather in his hat as a personal rebuke to the Nazis) he was confronted with the reality of Nazi occupation. His sister Catherine, now 25 years old, had joined the French Resistance. It's unclear whether Christian knew of his sister's clandestine work – until the inevitable happened when she was arrested in 1944.

On top of that, he discovered that in the meantime the work that he had been offered by Piguet had been taken by someone else. As Christian had been unenthusiastic in the first place, he wasn't unduly concerned and instead spent his time observing the drab attire of Parisian women. Seeing them as they 'made do' with what was available in wartime, including heavy shoes, fake stocking lines, and masculine-cut jackets, Dior was seized with a desire to return them to their former glory.

However, it wasn't long before another top couturier came knocking for him; this time it was the very grand Lucien Lelong, designer for the establishment elite. Lelong was having none of the Nazi nonsense about deposing Paris as the fashion capital; declaring that Paris haute couture would either stay in the capital, 'or it ceases to exist'.

Lelong was on the lookout for a modéliste, and

Strange times

Many Parisian artists and film stars had decamped to the south of France, and Christian soon found himself a new group of fun-loving sophisticates with whom to continue the charades parties of old. New and long-lasting friendships were born of this strange era with an aura of unreality, as arrests, deportations, denunciations, and executions lay heavy on all minds. Their antics also brought the police to their door, because Pétain had banned all such revelries in his zone. 'Work, family, fatherland', was his slogan, and anything that smacked of fun or artistic freedom, literary, theatrical, or cinematic, was frowned upon, with fashion, which seems to embody all forms of colourful freedom, at the top of the hit list. Indeed, the Nazis in Berlin were so displeased with the French couturiers that they raided the Chambre Syndicale de la Haute Couture, confiscating the archives. They wanted Berlin, of course, to take over as the centre of the fashion industry, along with Vienna.

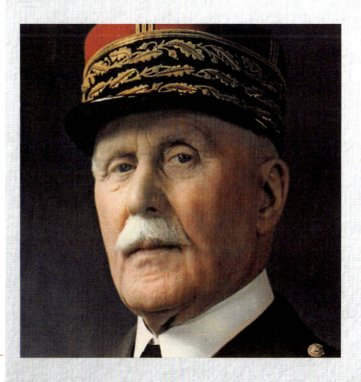

hired Christian, who was eager to gain the valuable experience of working with him. While he was there, Christian worked alongside Pierre Balmain, another man who would later set the fashion world alight.

Christian greatly admired the fearlessness with which Lelong faced the adversity of the Nazis, which included travelling to Berlin to try to persuade the Nazi hierarchy to see sense and not abolish the Parisian fashion industry. He largely won the day but couldn't prevent the German's insistence that no French designs could be exported or photographed. Consequently French *Vogue* ceased publication altogether, bravely unwilling to give into Nazi diktats. Lelong also gained the support of the French authorities and organised a fashion show in the unoccupied zone.

> Christian found himself part of an unofficial partisan fight back against dictatorship.

As Lelong's efforts bore fruit, the shortage of material was partly rectified when the government 'authorised' certain couture houses and permitted some exceptions to the fabric rationing regulations. There were still restrictions; only 75 outfits were allowed, with limited quantities of material, which enabled the Nazis to close any business accused of exceeding the quotas, such as Balenciaga in 1944.

Lelong had the satisfaction of seeing fashion industry sales rise fivefold between 1941 and 1943.

But most salons were beginning to look rather down at heel. A sense of gloom pervaded, even amongst Lelong's rather gaudy decor, of which Christian had never much approved. To Christian's frustration, Lucien followed the principle that what the client liked, the client should be given. For his part, Christian rebelled against any lowering of standards to suit the tastes of new nouveau riche customers who had made money unscrupulously selling agricultural products at sky-high prices. The result was that for several years both Christian and Pierre Balmain watched their designs die in front of their eyes. Not for the first time was artistic innovation defeated when creativity was pitted against commercialism. Dresses had to sell, after all.

This led Christian to ponder the question of how far artistic creativity could advance against the need for commercial product. With Lucien Lelong, Christian could see a master businessman at work, and watch as the lucrative American market, deprived of French fashion during the war, turned inwards and developed its own American-focused industry.

RIGHT: Pierre Balmain fitting haute couture gown on actress Ruth Ford, on 9 November 1947

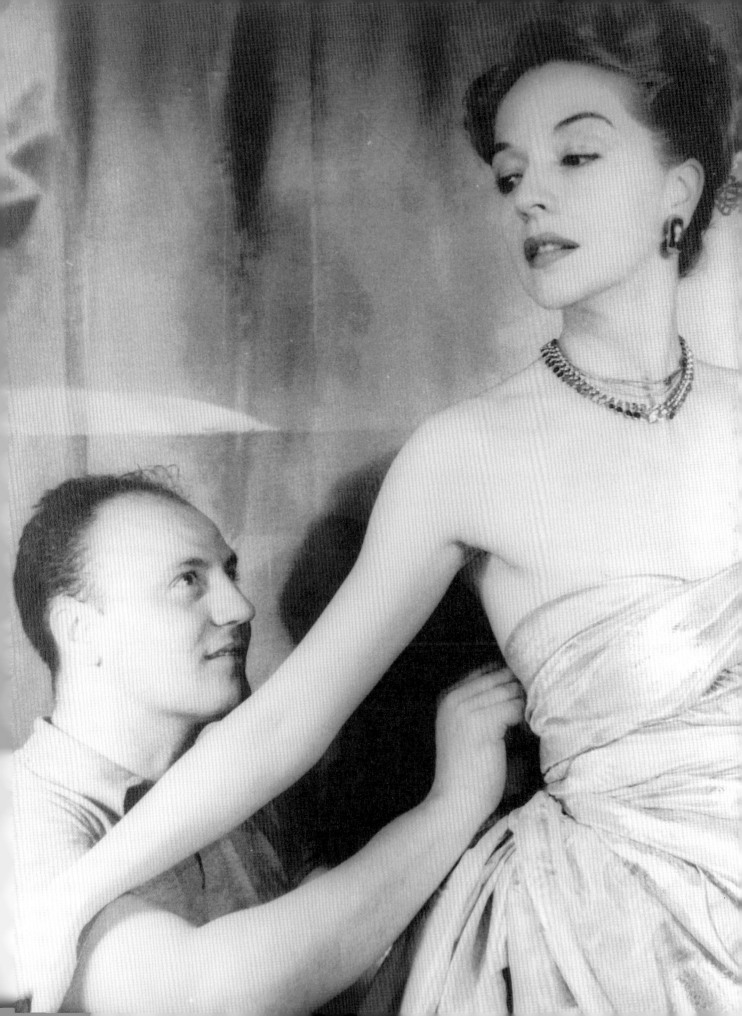

ASCENT INTO THE LIGHT 1945-1946

"A country, a style or an epoch are interesting only for the idea behind them."

The end of the war, and the liberation of Paris, brought to a halt the years of treading on moral quicksand when Christian and the other couturiers had designed clothing for the wives of Nazi officers and French collaborators.

The French realised that they would have to regroup and revamp if they were to survive in the post-war world, where wealthy customers now had a wide choice from an international industry.

Christian refused to believe that Paris would regain its foremost position in the fashion industry merely by following trends. He felt that maintaining its standards and reputation for perfectionism, and uniquely Parisian styles, would best ensure France always occupied a valued place in the fashion world. To help promote that special French flair, Lucien Lelong's Theatre of Fashion brought together the work of 53 couturiers and travelled throughout Europe and the United States, extolling the virtues of French couture.

Although he was not credited for the creations, Christian Dior had been involved in two of those designs, a turquoise and white dress with a swirling skirt and draped bodice, and an ivory tulle evening dress with embroidered leaves and flowers. Christian believed that 'You can never really go wrong if you take nature as an example'.

But despite the success of the event, Christian and Pierre Balmain had become acutely aware of an artistic ravine opening between themselves and their boss Lelong. They determined to do something about it when the time was right and even discussed partnering up. But in the event Pierre was the more determined of the two and jumped first, opening his own fashion house in 1945 and dazzling the likes of Gertrude Stein and the Duchess of Windsor with his collection.

RIGHT: Christian Dior amid some dummies in his atelier. Paris, 1940s

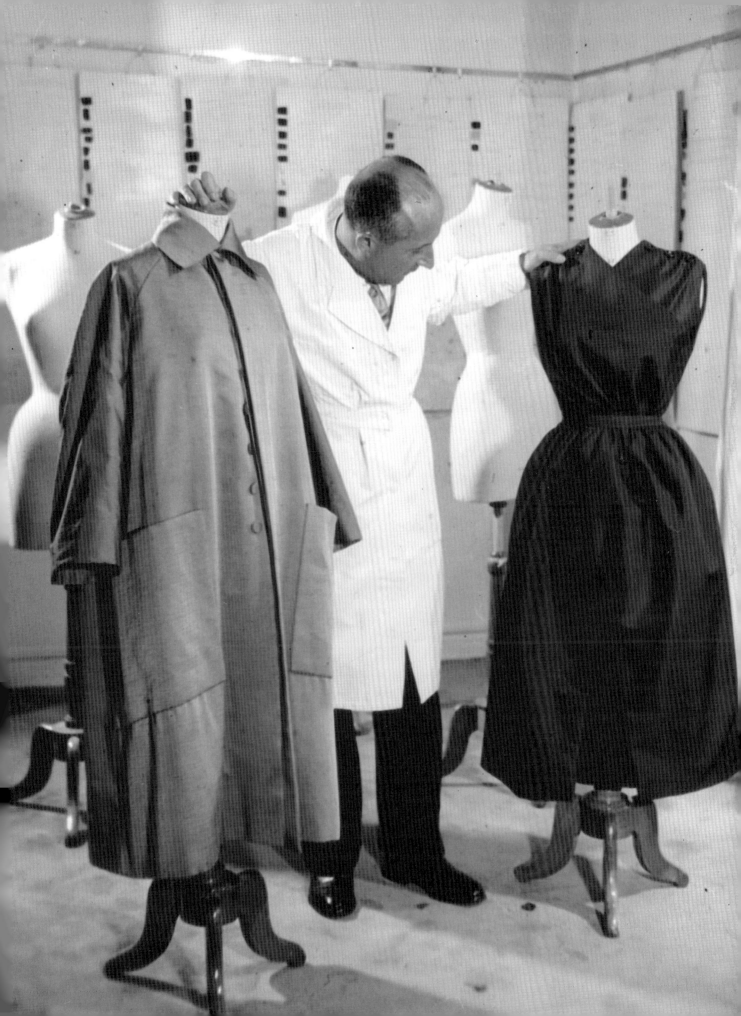

For Christian, 1945 brought relief in more ways than one; his sister Catherine who had been arrested in 1944 for her work in the French resistance, made it back from the Ravensbrück concentration camp north of Berlin. She was one of just 838 survivors from the last 2,600 people sent there with her.

Apart from that bright spot, Christian felt more dissatisfied than ever with himself and his work. He found solace by continuing to party with his friends.

Although famously unambitious, he was spurred on by Pierre Balmain's decision to go it alone. Eventually he became convinced that

Catherine Dior

Shortly before the Allies arrived to liberate Paris, Catherine had been arrested and tortured by the Gestapo before being sent by train with 2,600 others to the Ravensbrück concentration camp for women, north of Berlin. She was then given forced labour in German munitions factories under appalling conditions.

Fortunately for her and the Dior family, she made it out alive and in May 1945, she once again walked free along the Parisian pavements.

She was awarded several honours for her work in the resistance, including the Croix de Guerre, The Cross of the Resistance Volunteer Combatant and the UK King's Medal for Courage in the Cause of Freedom. She also became a chevalière of the Légion d'honneur.

After the war she worked with flowers, as a trader and a farmer, and lived to be 90. She and Christian remained close, with many people believing that he named his Miss Dior perfume in her honour.

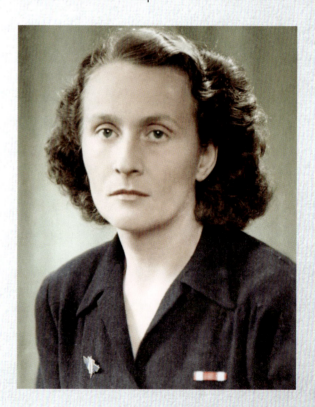

ASCENT INTO THE LIGHT

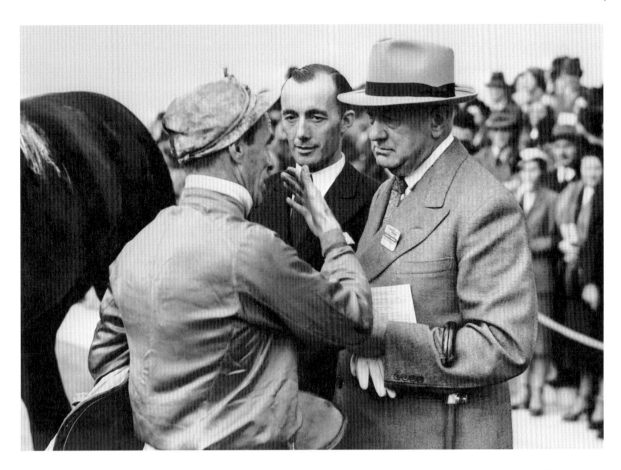

this was the only way that he, too, would find artistic freedom. But he never really explained how he finally found the courage to give up his job and go it alone, even in his autobiography.

But an opportunity presented itself when his friend Suzanne Luling mentioned Christian's name to one of the wealthiest men in France, Marcel Boussac, who was looking for a new designer for his enterprise, Philippe et Gaston couturiers.

Initially, Christian was hesitant, realising that if he were to stamp his own character on the company it would require sweeping away everything that smacked of the past. His low self-esteem made him doubt his ability to see through such an enterprise against the opposition it would surely engender. And anyway, he had really wanted to set up his own house and not bounce into somebody else's.

However Boussac wouldn't take no for an answer and, in July 1946, arranged a meeting. So it was that Christian found Boussac to be open to ideas and so began chatting freely about his thoughts on elaborate workmanship paired with simplicity, about returning to the luxurious traditions of the past. He also shared

ABOVE: French businessman and racehorse owner Marcel Boussac (R) speaks with French jockey E.C. Elliott during a Horse race in 1949

his belief that by exclusively making society ladies' clothes in the finest fabrics, in a small number of craftsmen's workshops, could lead the charge against mass clothing factories.

As Boussac listened to Christian wax lyrical about new ideas and direction, displaying razor-sharp aesthetic judgements as he poured out his knowledge of the last 40 years of fashion, he knew he had found his man.

Christian was to be given full rein to take over Philippe et Gaston.

But it was all too much for a nervous Christian who then flopped over into full panic mode. What had he been thinking? Who was this 'new woman' he'd enthused about? In a tailspin, he sent Boussac a telegram cancelling the whole arrangement.

But eventually he was persuaded to go ahead. His friends worked hard to soothe his whirling thoughts, his paralysing indecision, fear of independence, and of falling prey to a ruthless businessman.

As it turned out, Christian's genuine reluctance had worked in his favour, making Boussac consider him to be an even more desirable acquisition. So much so that he decided to back

Making a fortune

Tales abound about Christian Dior's fascination and belief in fortune tellers. The story goes that he first met a palm reader in Granville when he was a boy and she told him that he would one day succeed — through women. She saw him penniless one day, and later amassing great profits.

The prediction would prove accurate and seemed to fuel Christian's appetite for such mystical guidance as an adult. He was said to consult a medium before embarking on all his collections.

Eventually he would rely on the advice of a Madame Delahaye, who lived in the 16th Arrondissement of Paris.

Delahaye guided Christian on such key decisions as setting up his own couture house.

He was also interested in numerology and preferred 13 models when he presented his collections. He was also fond of the number eight, founding his house in the 8th arrondissement of Paris on 8 October. One of the lines in his Spring 1947 collection was called 'Eight' before becoming known as part of the 'New Look' movement.

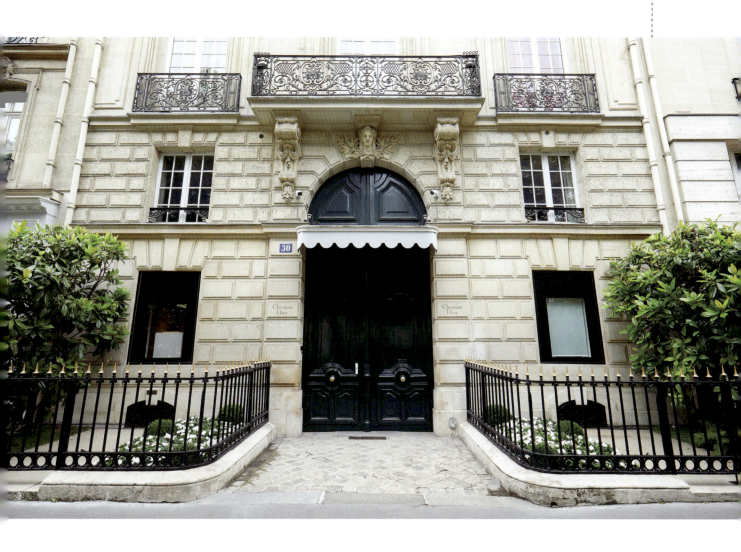

Christian in his own venture, Christian Dior Ltd.

With Boussac's six million francs in capital behind him and unlimited credit available, Christian's assault on the fashion citadels of Europe was now unstoppable. The name of Christian Dior was suddenly on everyone's lips as he was catapulted from unknown to the man to be seen with.

At 9am on 16 December 1946, Christian walked through the door of 30 Avenue Montaigne in Paris to start a new life; Maison Dior had been born. Christian had chosen the premises personally for its modest scale which, enabled him to form a 'very small, very exclusive house'. In acquiring it he had showed the forceful, stubborn side of his personality, because he had to battle against another couture house, Philippe et Gaston and then wrench Avenue Montaigne from their grasp, which he did quite ruthlessly.

Following the death of his father Maurice, just a week earlier, Christian was now on his own for the first time in his life.

ABOVE: 30 Avenue Montaigne

THE FASHION ICONS　DIOR

ONE NIGHT IN PARIS 1946-1947

"The precarious existence of a couture house is even shorter than a human lifespan."

Christian assembled a small management team comprising the crème de la crème of fashion at the time, including a 20-year-old Pierre Cardin as his chief tailor. Suzanne Luling oversaw the salons, Jacques Rouët was Christian's right-hand man and responsible for marketing, while Raymonde Zehnacker was head of his atelier. Completing the team was the superbly talented Marguerite Carré as technical director, whose 30 strong team of seamstresses transformed Christian's sketches into dresses.

Dozens more employees wandered in during the first day as workmen busied themselves with the renovations and everyone got down to work whilst trying to avoid choking to death in the dust. The next two months would bring improvisation, a race against the clock, decisions taken at a breakneck speed, and above all, backbreaking work.

One of the most difficult aspects of opening a new fashion house was finding customers with

Pierre Cardin

Pierre Cardin left Dior's employment abruptly in 1948 after being questioned by police investigating leaks of information about Dior's designs to copyists. Incensed that he should be suspected, the young designer left – to Christian's intense regret. However Cardin went on to become phenomenally successful in his own right, founding his own fashion house in 1950.

the right 'connections'. The utmost discretion was necessary, and with Suzanne Luling's help, Christian singled out high-wealth individuals within high society who would receive special attention. They chose 10 women each from England, America, Italy, and South America. Within France they had to proceed especially carefully so as not to poach customers from the other fashion houses. Winning over the Duchess of Windsor was a particular coup.

Dior and Boussac

With Christian Dior's success proving meteoric, the House of Dior reported a turnover of 1.2 million francs for 1947, its first year of operation.

In the following two years, Christian's backer Marcel Boussac showed his confidence in this unexpectedly lucrative enterprise by increasing his investment tenfold. In 1949, turnover increased to 12.7million francs.

But despite the success of their business arrangements, the two men never met again after their initial business meeting. Dior was but one tributary in the businessman's spread of commercial interests, a very gleaming one, run by a man whose talent he admired immensely and whose dresses Boussac's wife would buy – after a frisson of shock at the price tags.

Boussac moved in exalted circles; he was admitted to the presence of President Truman to discuss Western Europe's future, not least the frightening scale of inflation in Germany, and France's unemployment problem. But as Christian's business associate Jacques Rouët pointed out, Christian 'was a manager come artist and he dominated everyone else through stature, his intelligence, and his talent.' The only way to ensure that two fiercely individualistic personalities did not unintentionally mangle the House of Dior was to keep them apart. Boussac's team ensured that their boss didn't ever see the telegram Christian sent when he had cold feet about the initial deal.

Although Boussac had agreed on the staff costs of the expensive management team, no money was allocated to the vital task of publicity; 'I relied on the quality of my dresses to spread the word', said Christian. He had quickly proved to be an astute businessman and organiser and the 'Dictator of the hemline'. His credo was to be discrete, rather than explosive and he directed his enterprise and employees with confident commands and quick gestures. His speech was peppered with expressions taken straight from the military, as he spoke of 'mobilising' his thoughts, 'standing firm' or being 'on guard', at the same time waving a pointer topped with a gold-ringed knob.

Even before the inauguration of his 'maison', Christian had agreed to launch his first perfume, in tandem with his friend Serge Heftler-Louiche, who ran his own perfume distribution company. In what has been commonly assumed was in tribute to his courageous sister Catherine, Christian named his first perfume, *Miss Dior*.

When time came for opening, the small building on Avenue Montaigne was overflowing with models, dresses and staff and the atmosphere became heated and stressful as everyone rushed to try and solve the myriad problems that arose. Not the least of these was Christian's insistence that his dresses were 'constructed', meaning that the seamstresses had had to relearn forgotten techniques. Taffeta and cambric lined all his pieces as Christian wanted to mould his fabrics to the female curve, 'emphasising the waist or the width of the hips, highlighting the bust'.

Then, workroom staff all over Paris went on strike four days before the opening and Christian's building was besieged by workers insisting his employees join them. With anxiety at an unbearable pitch, more of Christian's friends and acquaintances came to fill the places of the missing seamstresses. Christian rose above it all, stating later, 'I had nothing to lose, really. The public could hardly be disappointed, they didn't know me, they had no expectations and demanded nothing from me'.

His friends however, knowing his work, did expect extraordinary things. They insisted on a preview of the collection, which filled Christian with more trepidation than the main event itself. He was rewarded with overflowing enthusiasm from the likes of Count Étienne de Beaumont and his friend Christian Bérard, who told anyone he clapped eyes on about the show, including Bettina Ballard of *Vogue*.

The opening was on 12 February 1947 - a day that would change fashion history.

RIGHT: Christian Dior, 1940s

The rich and famous attendees included Marlene Dietrich, Margot Fonteyn, and Lady Diana Cooper, amongst other baronesses and wives of wealthy men from home and abroad. The imminent sense of success and money permeated rapidly through all layers of society.

Outside the building, the hard-nosed ladies and gentlemen of the press gathered, irritated at being kept waiting for what they considered just another showing in a long series that they had visited. When they were finally allowed in, they were struck by the opulence and gentle scent of *Miss Dior* in the air. The 'bullfight', as Suzanne Luling described the press showing, got underway, and after the grumbling about seat placement, the stopping and shaking of hands, the gossip and excitement, the journalists fell silent as the first dress was announced.

Christian had chosen his star model Marie-Thérèse for the honour of being the first out for his 90-piece collection, called 'La Ligne Corolle' – The Flower Line, featuring lifted busts, softly sloping shoulder lines and long, bell-shaped skirts.

Suddenly, the space was filled with twirling, flouncing skirts and endless

THE FASHION ICONS DIOR

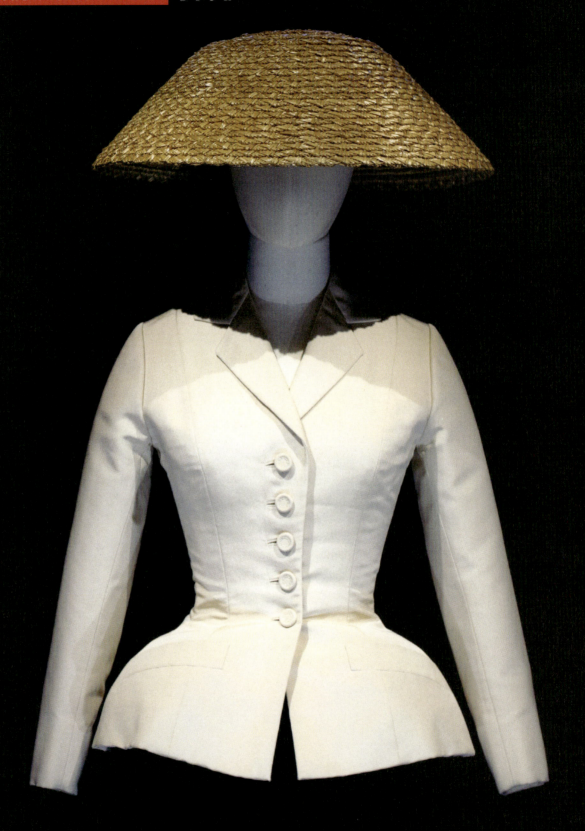

ABOVE: Christian Dior's 'bar jacket' on display at the Christian Dior: Designer of Dreams exhibition, Brooklyn Museum in New York, on September 7, 2021

yards of fabric producing flair, sensuality and confident chic. Unashamed femininity took the spectators' breath away as this flirtatious fantasy world swayed and flowed in front of them, generating loud calls of 'bravo'.

Christian's creativity carried all before it, with his opulent collection introducing the legendary Bar Suit, the 'Tailleur Bar' ensemble. The jacket's softened shoulders and padded coattails flaring from the hips, was actually a modern version of something Chanel had created before the war. It was Dior's pleated skirt that measured 19 meters in diameter at the base that many Parisians found insulting to the post-war austerity still endured by the majority.

But the excellence of the theatricality was much appreciated by Carmel Snow of *Harper's Bazaar*, and even Bettina Ballard of *Vogue* was caught up in the 'magic' of Christian's 'complete conquest'. Snow showed her delight immediately, telling Christian that he had started a revolution. 'Your dresses have such a new look', she said. 'They're quite wonderful you know.' They should have been as they were almost sculpted and produced with the highest levels of embroidering and tailoring possible.

Thus arrived the dawn of a new era, the era of the 'New Look' with Christian Dior crowned the king of Parisian couture. Glancing nostalgically back towards the Edwardian and Belle Epoque eras, Christian refined skirt shapes and waistlines that had found favour at the latter end of the 1930s. Dior then accentuated the hourglass figure and the curvaceous form, pairing elegance with glamour, sophistication, and sumptuous materials with charm.

'We were emerging from a period of war, of women built like boxes,' explained Christian. 'I drew women the flowers, soft shoulders, fine waists like liana and wide skirts like corolla.'

As he overthrew the domination of the boxy forms that had characterised the pre- and inter-war years at the hands of designers such as Coco Chanel, it was small wonder that Chanel was somewhat peeved at this turn of events.

'Look how ridiculous these women are', she sniped, "Wearing clothes by a man who doesn't know women, never had one, and dreams of being one". She topped that off with, ‹Dior doesn't dress women, he upholsters them›. She was overruled by the women who streamed in to buy the luscious creations.

However, there were many that agreed with Chanel in the US, where some women were not quite sure they wanted their legs covered

THE FASHION ICONS DIOR

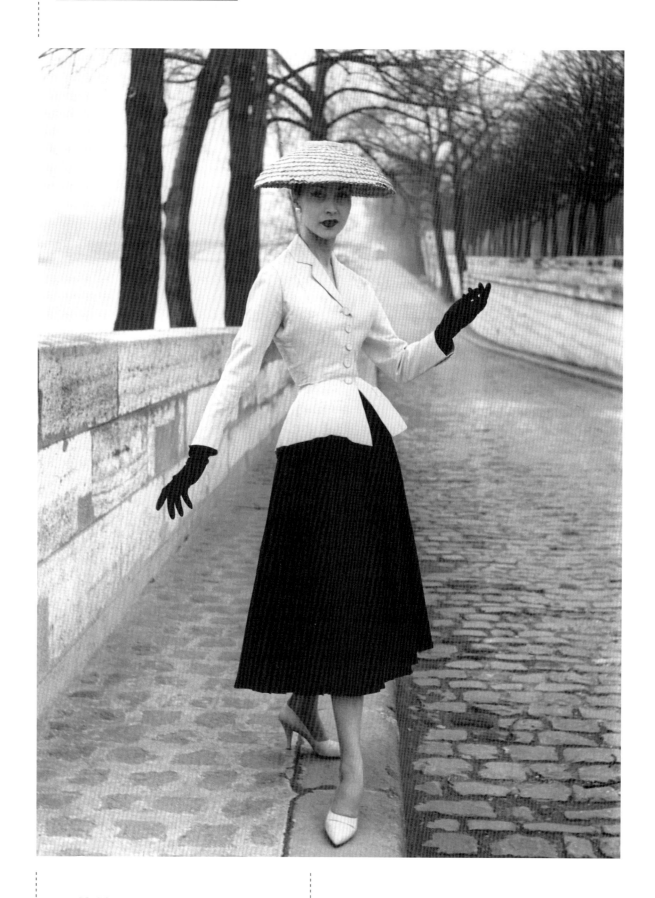

ABOVE: Model wearing Dior's 'bar jacket", 1947

ONE NIGHT IN PARIS

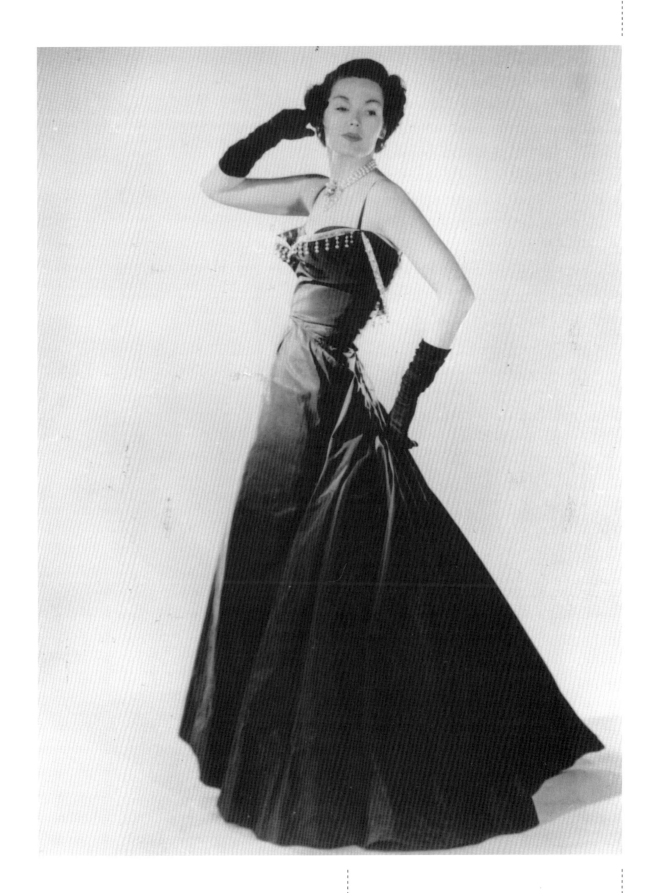

RIGHT: Barbara Goalen in evening dress by Dior, 1947

A 'Little Below the Knee' club was formed and its members paraded the streets with placards reading 'Down with the New Look', 'Burn Monsieur Dior!', and 'Christian Dior: Go home!'. A former American model was quoted as saying, 'Whoever dreamed up this fall's gruesome styles has been reading too many historical novels'.

But the protests were to no avail. Paris had stormed the barricades. By the autumn of that year, Dior had prevailed even in America.

For the première of her new movie, *Gilda*, Rita Hayworth selected a Dior evening gown, the Soirée with its two tiers of pleats in navy blue taffeta. Margot Fonteyn bought a suit. Even the British royal family fell under his spell and invited him to stage a private presentation in London, although the Princesses Elizabeth and Margaret were forbidden by their father King George VI to buy anything for fear that it would set a bad example in those austere times when rationing was still in force in the UK.

Marlene Dietrich, who also lived on Avenue Montaigne, became a devoted fan, uttering another immortal phrase which was 'law' for all her film costumes: 'No Dior, no Dietrich!'.

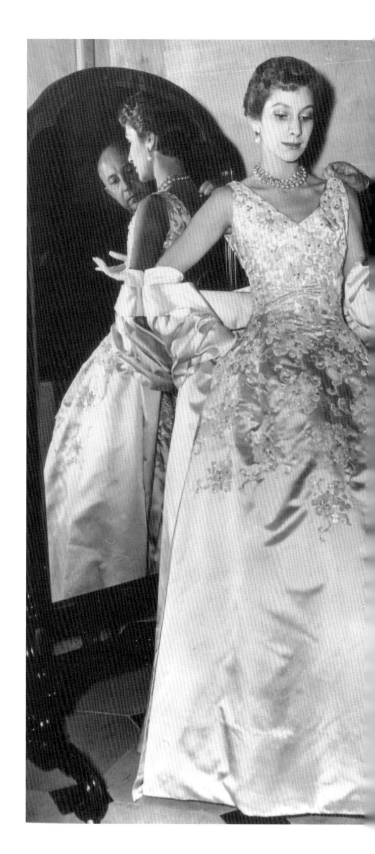

ONE NIGHT IN PARIS

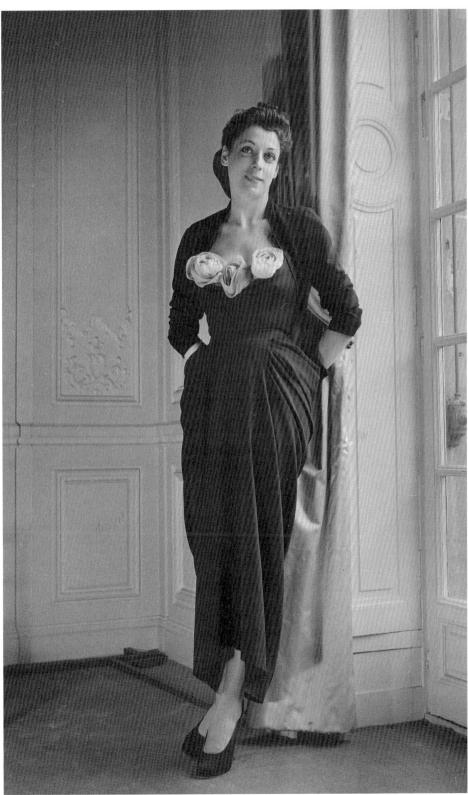

A. LEFT: Christian Dior adjusting evening dresses, 1940s
A. RIGHT: Denise Duval, French opera singer, in a dress by Christian Dior. May 1947

THE GIDDY HEIGHTS 1947

"I could never have foreseen the reception it was about to receive. I had so little inkling of it but I'd simply tried to do my best."

It seemed the entire world was beating a path to 30 Avenue Montaigne. The American buyers returned cap in hand, chagrined at having missed the 'cataclysmic event'. Dior could not turn around without meeting another celebrity such as the actress Olivia de Havilland, who was very drawn to a navy-blue wool crêpe Passe-Partout suit. The Bar suit was hugely popular and accompanied by a cheeky, black pillbox hat. The black wool and fastened bodice of the Corolle pleated dress, with its five buttons, was also much sought-after, as was the Africain, a panther-print long muslin gown. Acting royalty, Laurence Olivier and Vivien Leigh, paid a visit.

The name of Christian Dior was on everybody's lips, he had become a household name as famous as the Eiffel Tower. He had purposely aimed for the high end of the fashion market but, with garment manufacturers falling over themselves as never before to meet demand from the woman in the street, Christian's creations could now be seen everywhere. Even young people were excited about his New Look, including left bank artists and intellectuals; singer Juliette Grèco, for example, was one of those who would think nothing of spending 120,000 francs for one of those outfits.

Christian was offering women all that they had been deprived of during the grim war years, wide skirts, narrow waists, long dresses. He was not attempting to be a revolutionary, it was against his nature to intentionally make headline-grabbing gestures or shock gratuitously. Listening more than speaking, never pushing himself to the fore, always aware of the needs of those around him, he valued discretion, tradition, beauty, fantasy even. But he also possessed sensitive antennae for the ebb and flow of the era, his collections echoing in cloth the words of Francoise Giroud, who would become minister of culture, when she wrote that fashion died from disenchantment and was born of desire.

Above all, however, Christian Dior was an artist who dreamed of spreading happiness - his first dresses were called Love, Tenderness, Corolla, and Happiness, after all. War over, it was time to dream again.

RIGHT: Christian Dior illustrates skirt-hem length on a model. This length characterizes the New Look trend, 1947

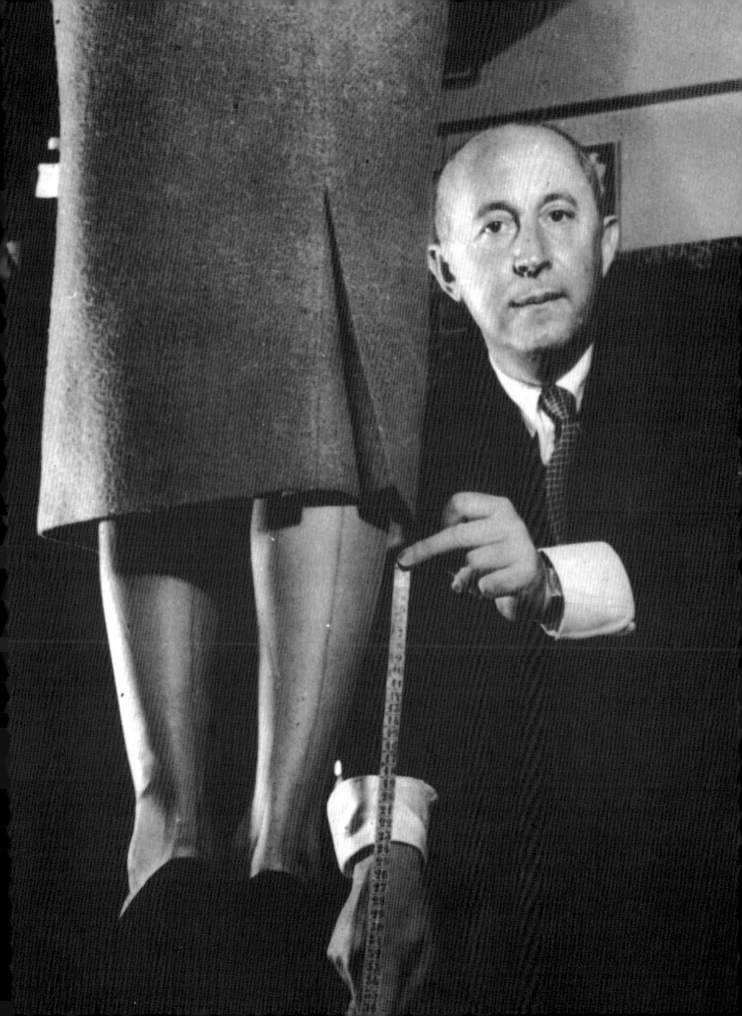

The demand for his collections meant that the buyers had to be seen at night once the individual clients had left, which meant staff often worked as late as 3am. It was soon obvious that Dior's premises were too small for the demands put upon it, so a new seven story building was built to accommodate additional workrooms.

Despite his success, Christian remained level headed; he would pursue his own path as he had done with his collection, neither swayed by success, nor envy, nor life's vicissitudes. On 6 August 1947, Avenue Montaigne was once again home to exciting scenes as Dior's second collection was shown. This time the Americans had learned their lesson and were out in force to see Christian triumph once again with his 'breath taking and supremely elegant' styles. He had not played safe, nor shied away from the possibility of being viewed as a one-night wonder but followed his instincts and taken 'the famous New Look to the furthest extreme', using 'unimaginable' amounts of fabric, and this time dropping the hems right down to the ankles.

With a circumference of 17 yards, the standout design in this collection was a black wool dress highlighting all that was feminine, 'designed to enhance the proportions of the female body'.

Christian's creations were deliberately leading women away from the flatlined forms of Chanel and the extravagance of Schiaparelli, which became démodé almost overnight.

As the world seemed ready to lurch into more conflict with the 'Cold War' between America and Russia, Christian felt that his style of couture was more necessary than ever. He felt that he and Western Europe had more to offer, saying that 'In the face of an uncultivated, hostile world, Europe is becoming aware of itself, its traditions and culture'.

And Europeans who could afford them clamoured for his little-girl-style dress with its puffed sleeves, bouffant skirt, and its slim length, flat-chested torso shining from top to hem in grey silk faille. Also popular were the necklines plunging to just above the raised waistline of a cocktail dress in black crepe; and of course, the back-to-front hats.

Black was the one thing that he and Chanel both agreed on. "You can wear black at any time,' Christian said. 'You can wear it at any age. You may wear it for almost any occasion; a "little black frock" is essential to a woman's wardrobe.'

RIGHT: Christian Dior full skirted green velvet coat with tight belt, gold and silver embroidery over slant pockets and deep leopard skin cuffs on three quarter length sleeves. 1947

THE GIDDY HEIGHTS 61

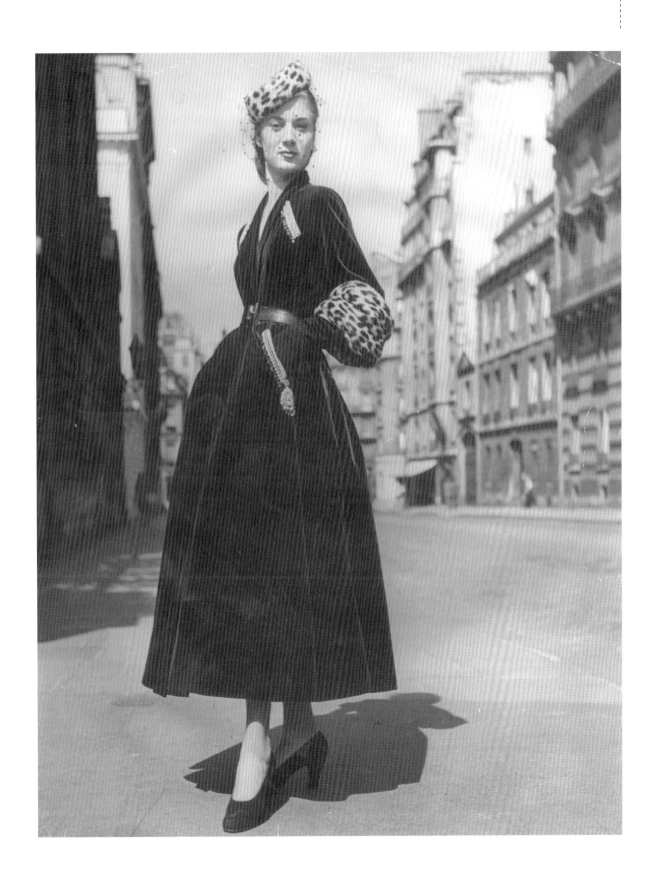

THE FASHION ICONS DIOR

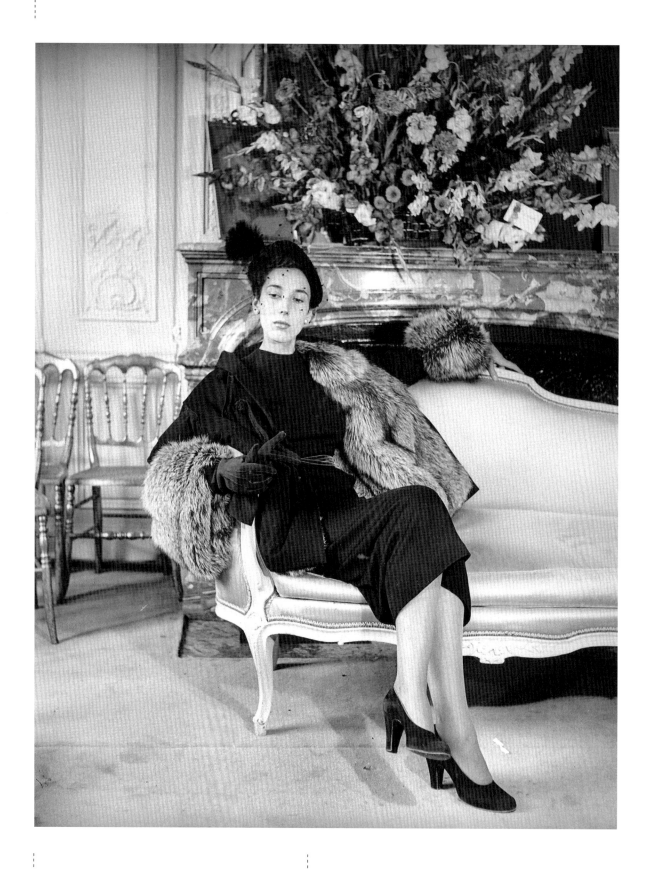

ABOVE & RIGHT: Models wearing Dior's "New look" designs at Christian Dior. Paris, August 1947

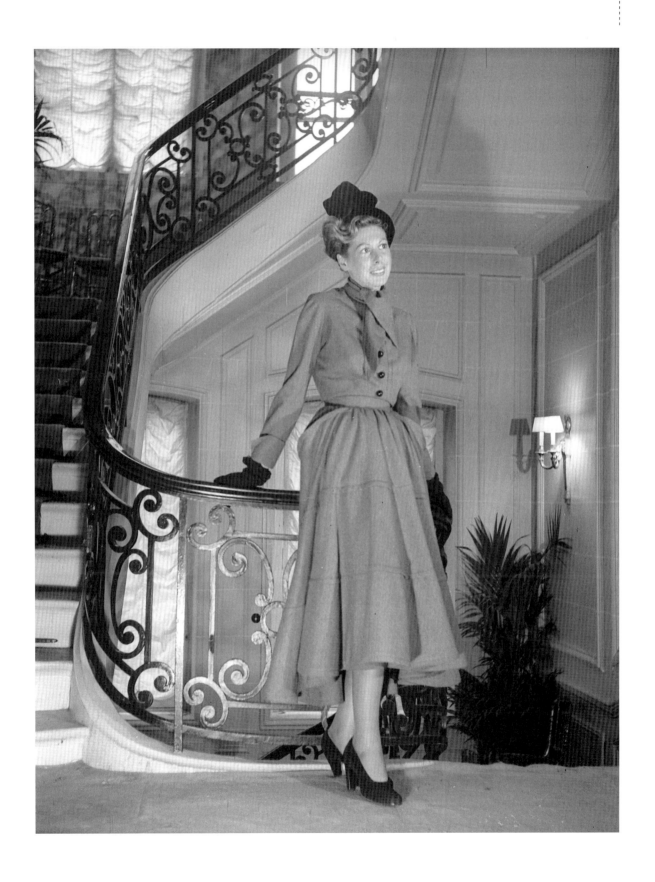

GLAMOUR GALORE! 1947

"Women, with their sure instincts, realised that my intention was to make them not just more beautiful but also happier."

As Paris recovered from the war it was awash with Americans, heiresses and the wealthy of the world and Christian Dior's business flourished accordingly.

The 1951 Gene Kelly film *An American in Paris* epitomised how the Americans imagined the city to be. Suzanne Luling, who seemed to be friends with, and loved by, everyone from Marlene Dietrich to the American fashion buyers and the difficult press hounds, similarly embodied French sophistication. She and her friends were frequent visitors to left-bank nightclubs with her coterie of friends, whilst those in high society indulged in spectacular balls, soirées and dances with wild abandon akin to that which had gripped Berlin after the First World War.

Christian was in the thick of it all, as he had been in his youth, except that now the costumes were made to measure and luxurious in the extreme. He was in his element, designing gowns inspired by the 16th century Italian artist Veronese and the 17th century painter Antoine Watteau as outfits for the many costume balls held at the time. A stunning creation for the Baroness Alix de Rothschild transformed her into a shepherdess, draped in yellow and caramel with a bodice over a wide crinoline skirt edged in black ribbon. He turned his old friend Henri Sauguet into Cardinal Richelieu, and Viscountess Noailles into a barmaid; albeit one in very expensive Dior clothing.

Christian himself wore a King of the Beasts costume, designed by Pierre Cardin, at a ball hosted in 1949 by Count Étienne de Beaumont, which proved to be the count's last. Étienne's appetite for dressing up matched Christian's, and he spent many hours designing jewellery for Christian's collections. His gilt drawing rooms had been open to artists and nobility without discrimination. Christian valued these gatherings saying, 'Parties like these are genuine works of art'. They were also the last tailwinds of a bygone age, gently lingering amongst the privileged, and which would pass away with them.

Dior's Maison de Couture gradually became an indispensable stopping-off point for the jet set

RIGHT: Christian Dior, 1940s

in their tireless circumnavigation of the globe. Avenue Montaigne continued to welcome a stream of arrivals from amongst the wealthy and famous of the world; Barbara Hutton, Gianni Agnelli, Ali Khan, Élie de Rothschild, and the Duke and Duchess of Windsor among them. Artists, aristocrats, nouveau riche, intellectuals, ambassadors, they all floated in and out of the salons and each other's houses and bedrooms; no one flinched any longer at the open democratisation of love affairs. Christian employed this democratisation to his benefit by recruiting saleswomen and models from amongst the ranks of the wealthy and aristocratic.

Dior's devotees

Even in more modern times, The House of Dior counts many of the most beautiful women in the world amongst its representatives, including:

Sharon Stone

Charlize Theron

Natalie Portman

Jennifer lawrence

Rihanna

Jisoo from BP

Men who have fronted Dior campaigns include:

Jude Law

Robert Pattinson

Johnny Depp

Jimin of BTS

Christian was firmly embedded in the world of the beautiful, the rich and the celebrated. He became a one-man advertisement for the resurgence of Parisian culture, and his conquering of America benefited other French artists as well, including singers Yves Montand, Édith Piaf, and Charles Trenet, and writers Jean-Paul Sartre, Simone de Beauvoir, and Antoine de Saint-Exupéry.

Atop this revival of glamour, Christian Dior himself was rather inconspicuous with his pear-shaped body and moon-shaped face topped with a bald head; not so much a Parisian dandy, as more of a country doctor look, as Cecil Beaton described him. And, indeed, Christian remained as discrete as a country doctor, almost never leaving his refuge in Avenue Montaigne to meet his clients and taking great care never to be seen accepting their grateful thanks personally for fear of arousing jealousy amongst those who had not been so fortunate as to meet him, or thank him, even. The socialite Gloria Guinness and the British Princess Margaret were two exceptions to this rule.

London was still coping with the aftermath of the second world war, and the long arm of austerity could be seen in the clothes that

LEFT: Yves Montand
RIGHT: Édith Piaf

women wore and their relative indifference, if not to style, then certainly to expensive and ever-changing fashion tastes. There had still been restrictions on fabrics in 1947, and the New Look had been greeted with scepticism, almost equal to America's. But then, in Britain too, Dior broke through thanks to the Dereta Fashion House, which managed to manufacture 700 New Look suits, which sold out in a fortnight. There was even a private showing for the Queen Mother, Princess Margaret and the Duchess of Kent.

When Princess Margaret was photographed by Cecil Beaton for the cover of *Paris Match* to mark her 21st birthday, she wore a Dior ball gown. Christian – now holding the French Legion of Honour award for his contribution to the fashion and textile industry – asked the princess whether she felt 'like a gold person or a silver one?'. Margaret replied, 'A gold person' and hence, was radiant on the day in Dior's 'Oblique' line from the spring of 1951, when 300 hours of work in Dior's workshops produced a boned bodice of white silk organza over satin. One shoulder was free, the other bathed in "a sash ending in a loop to be worn on the upper right arm, almost as if it had dropped", according to the Museum of London.

The skirt was voluminous, consisting of seven layers gathered to embrace a 22½-inch waist. There were three layers to the silk inner tube, which was made of stiffened net with two outer

ABOVE: Dereta Fashion House adverts

layers of organza and a superbly embroidered front panel. The gown reflected the princess's wish for gold, although the main materials are a dull raffia and sequins made of wood pulp covered in straw. Shiny mother-of-pearl, sparkling metal sequins and rhinestones complete the effect.

There was another highlight to suit Dior's delight in elevated society, when, in 1952, he was asked by the Duchess of Marlborough to consider a fashion show at Blenheim Castle in England. He was happy to take the chance of using that magnificent country home as a backdrop for his designs. It was remembered as a day of extraordinary glamour as the girls strutted the catwalk; even Princess Margaret was present.

The Duchess of Windsor was eager to get herself into a Dior dress, but, not wishing to look as desperate as everyone else, she waited until the following season to do so. Meanwhile Nancy Mitford was in the vanguard of those wearing the 'New Look' in London.

It was obvious that Christian was a snob, something made plain when he was approached by French film producers to clothe one of their greatest upcoming stars, a young actress called Brigitte Bardot. No amount of entreaty could move the heart of the man who felt the peak of achievement was to dress duchesses, countesses, princesses, aristocracy of any kind, to take on a young film star. She was not even Italian, and Italian women displayed elegance par excellence in Christian's eyes.

When it came to designing for film or theatre, Christian had been uncertain about becoming involved at all – he did not want to give his aristocratic clients the sense that they were not

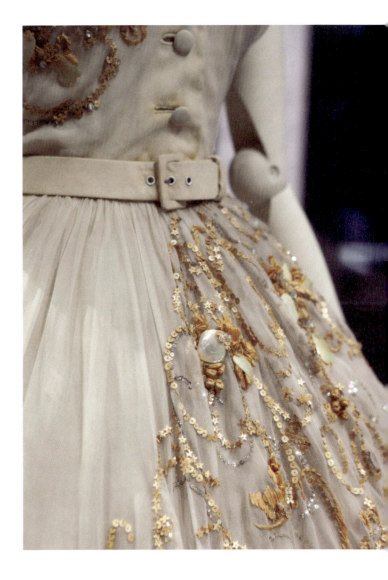

ABOVE: Princess Margaret's 21st birthday embroidered dress on show in the 'Christian Dior: Designer of Dreams' exhibition at the V & A Museum

exclusive by clothing mere actresses. However he had let himself be seduced into designing costumes for films such as *Lettres d'amour* and *Le lit à colonnes* in 1942, and the *Le silence est d'or* and *Pour une nuit d'amour* in 1946. In 1947 he took the chance to use crinoline for the gowns he designed for Yvonne Printemps in the play *La Valse de Paris*. His final foray into the world of theatre was in 1953, when he again designed for a play in Paris, *Pour Lucrèce* by Jean Giraudoux, who had died in 1944. Christian struggled with theatre costumes because he had to put his desire for perfection second to the necessary emphasis on the visual effect of a costume – a fact that caused him great distress

The film industry profited to a greater extent from his dressmaking skills, and Marlene Dietrich, of course, was his greatest advocate, wearing swathes of Dior in such films as Hitchcock's *Stage Fright* and *No Highway in the Sky*. Olivia de Havilland was another faithful client for whom Christian Dior also designed a wedding gown. Ava Gardner wore 14 of Dior's dresses in *The Little Hut* and Myrna Loy was another of the stars who benefited from the glamour that Christian's designs lent on screen.

If you wished to be one of Dior's models, it certainly did no harm to come from aristocratic stock. Dior liked Martine Dewavrin, and Maxime de la Falaise, the daughter of Count Alain de la Falaise, slim as a reed and a favourite in American fashion magazines. But his house muses were women such as Kouka Denis, Marie-Thérèse Walter and Lucie Daouphars. Christian felt fatherly towards them as he nurtured them and turned them into stars; Tania, was one woman who was launched by modelling for him, as was another he named Victoria, and Odile Kern, who remained with him for eight years as one of his key models. And no, said Christian, he did not undress them with his eyes, rather he 'dressed them in something else'.

ABOVE: A Christian Dior design for Yvonne Printemps in La Valse de Paris

RIGHT: Marlene Dietrich in Hitchcock's Stage Fright

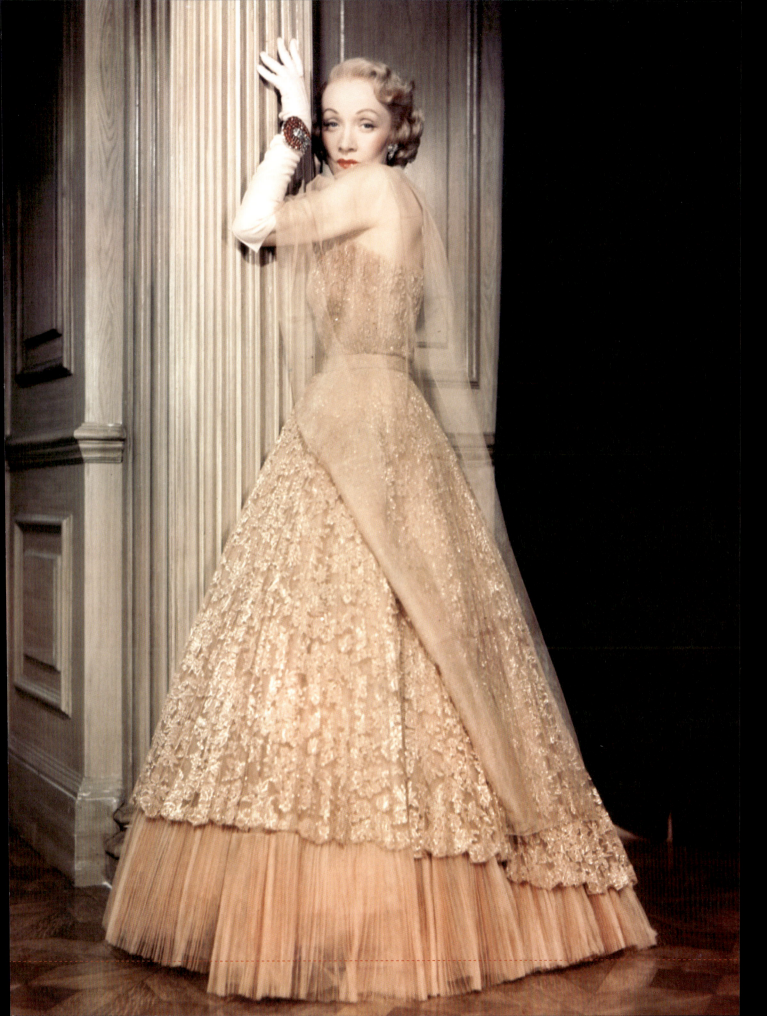

DIOR'S QUEENS OF THE DAY

"They are our glory, our muses, the ones we fight over, envy, love and admire."

Christian Dior benefited from the untrammelled extravagance of the wealthy, women who would think nothing of buying 100 outfits a year.

One woman, thanks to the deep pockets of her South American husband, bought 'three evening gowns, five cocktail dresses, six coats and twelve suits' from Dior for a trip to Europe, on top of purchases from other couturiers. Such extravagance flabbergasted even Christian himself.

Making his feelings clear in rather schoolmasterly terms, chastising the lack of decorum in such self-indulgence, he pondered in his first book *Je suis couturier*, 'What are the duties of a client towards her couturier? To choose dresses that show her to her best advantage. If they should fail to do so, she is doing a disservice both to herself and the good name of the firm'.

This represented a ticking off for those customers who didn't know their own minds or were never satisfied. Christian was clear that he was not going to bend over backwards for them, the women who almost bankrupted themselves just to own Dior – although it was good for his business.

The wasteful luxury enraged the increasingly vocal feminist movement. Jean Cocteau, too, was seriously disgusted that all anyone wanted to talk about was Christian Dior – which just goes to prove how omnipresent the designer had become. Included among his 25,000 clients a year was Mrs. Randolph Hearst, wife of the newspaper magnate who made Dior her chief couturier. She described him as creating 'great art' and loved the construction and the finishing of his clothes.

Now thrust to the pinnacle of fame and fortune and desirability, Christian professed to longing for a modest lifestyle, which is what he had originally thought would be his; 'if only I were Balenciaga!'.

Spanish fashion designer Cristóbal Balenciaga was another giant of the fashion industry at the

RIGHT: Cristóbal Balenciaga design from 1947

Photographer Cecil Beaton on Christian Dior

A 'bourgeois with his feet well planted in the soil, in reality he has remained modest... In spite of eulogies ... his sage-like head sways from side to side, but it will never be turned by success.' The words of photographer Cecil Beaton, who admired the fact that Christian never allowed the fame and compliments to cloud his thoughts and swell his ego.

time and someone Christian greatly admired, and perhaps even envied. Cecil Beaton thought Balenciaga was the Picasso of the fashion world, whilst Dior was Watteau, delicate and nuanced. It was a battle royal.

Sombrely frowning upon the raging excess frothing in Avenue Montaigne, Balenciaga became so aggravated when women came to him from other couturiers, that he refused to make an appearance at the end of his shows, so contemptuous was he of those of his faithless clients who had jumped ship.

Balenciaga's lines tended towards the linear, towards sleekness, swerving away from Dior's hourglass shape. He absolutely could not condone 'maligning' a piece of fabric with stiffened tulle or the rigidity of canvas, as he felt that Dior had done. Yet despite being at

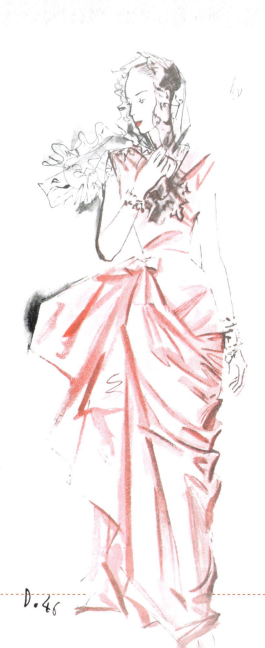

the opposite ends of the design spectrum, both designers were inspired by each other, while remaining determinedly individual. They shared a mutual respect and affection for the other; sentiments reflected in Dior's actions when Balenciaga decided to close his business. Seeing his rival as essential to Paris fashion, Christian engaged Balmain to help him persuade Balenciaga to change his mind, even buying him a Braque drawing to assist their efforts, but to no avail.

While he wasn't about to sell up in Paris himself, Christian did feel that he needed a refuge from the stresses and strains of his business life, and so he acquired a home – a renovated mill, the Moulin du Coudret, in Milly-la-Forêt, an hour outside Paris. There, planted firmly in the typical French countryside that his mother would have loved, he could - with his Polish gardener Ivan - arrange the first of his own gardens, 'simple and modest', to reflect the 'peasants' gardens that decorate the sides of the roads in my native Normandy", as well as, because he was an Anglophile, an English-style garden.

Christian turned the house into a shrine to his parents and a childhood lost, a citadel against the harsh modern world. He scoured flea markets and chose light-coloured fabrics, whites and greys, to replicate the bucolic charm of a rustic house. It was in this hideaway that he would play piano and cards and enjoy relaxed afternoons with the likes of Marlene Dietrich and Jean Cocteau.

In 1951, Christian acquired another property, the Château de La Colle Noire, in Montauroux in the south of France, 40km from the glamour of Cannes. He became particularly fond of spending time at this place, and it was here that *Miss Dior* came into being. As Christian put it, 'She was born from those evenings of Provence crossed by fireflies where the green jasmine serves as a counter-song to the melody of the night and the earth.'

ABOVE: Early Miss Dior bottle
RIGHT: Cristóbal Balenciaga

DIOR'S QUEENS OF THE DAY 75

Once he had restored the 'hole in a swamp' – although it was, in fact, 'a place that was never beautiful enough, never finished, always in progress' – he relaxed there, played cards, made liqueur, donned boots, and rolled up his sleeves to restore the gardens. As well as setting out flower and vegetable sections, he installed a grand ornamental pool and planted 150 almond trees, recalling the garden of his childhood and his mother. No expense was spared in turning the old house into an estate fitting for a man of status and means.

As his fame increased, Christian became more and more engrossed in the beauty of nature, so that the curves of a flower and the soft flow of rose petals found their way into his couture designs. He found that he worked well in the country where he would often prepare his preliminary sketches for another collection. Few people were invited to his country homes, his closest colleagues being the only ones privileged to visit – Raymonde Zehnacker, head of his atelier, was one of them.

Christian considered life without Raymonde as unthinkable. As he wrote in his 1951 autobiography *Je Suis Couturier*, 'Raymonde was to become my second self. Or to be more accurate, my other half. She is my exact complement: she plays reason to my fantasy, order to my imagination, discipline to my freedom, foresight to my recklessness, and she knows how to introduce peace into an atmosphere of strife. In short, she has... steered me successfully through the intricate world of fashion, in which I was still a novice in 1947'.

Raymonde was the one permitted to enter his room first when, after days of incarceration, a proliferation of Christian's rough sketches were ready to be viewed and interpreted and the bare bones of a collection would emerge. In the depths of his insecurity, he needed her diplomatic pillar of strength around him to admire the latest emanations from his creative brain.

Eventually, though, he became too anxious when he was away from Paris for any length of time at all, and he no longer found recuperation amidst the gentle sounds of the countryside.

RIGHT: "Treize danses", decoration and costumes designed by Christian Dior, 2nd from left. Ballets of Champs-Elysees, November 1947

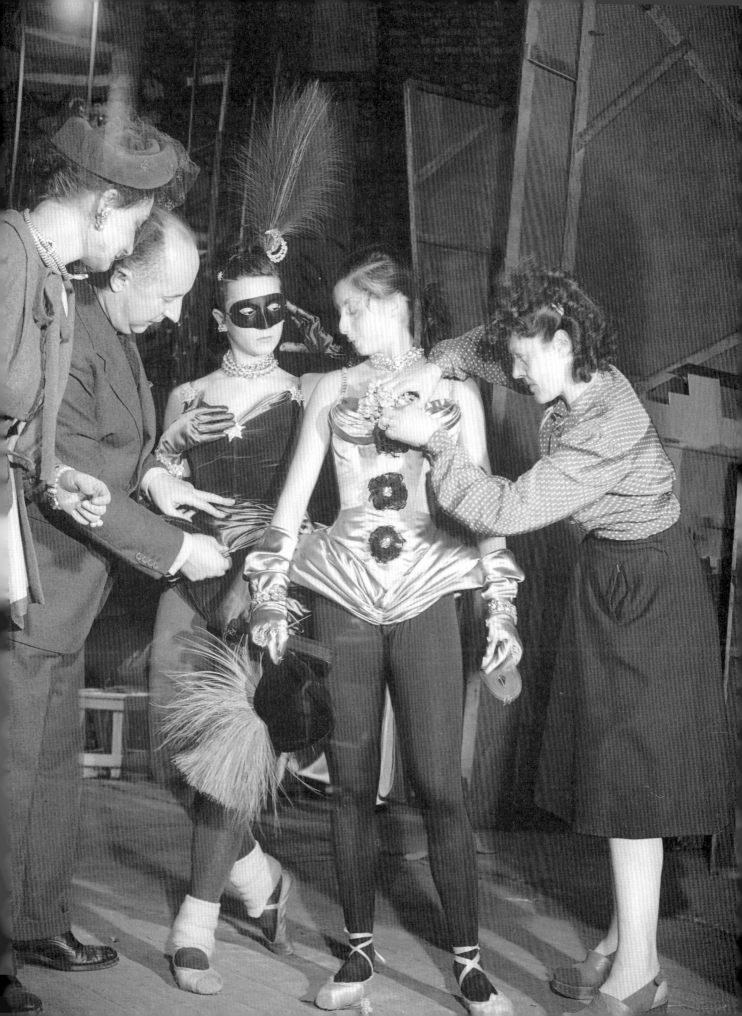

THE FASHION ICONS — DIOR

GO WEST, MIDDLE-AGED FRENCHMAN! 1947

"The American women will accept the new fashions."

Another event in the turbulent year of 1947, was Christian's trip to America. Already tantalised by this confident country and its women forging ahead into a new post-war future, America also happened to be home to his biggest buyers. The catalyst for the trip was an invitation from the managing director of Neiman Marcus, Stanley Marcus, who had awarded Christian the company's 'Oscar for Couture'. This award had been inaugurated during the torment of the Second World War, and Christian was more than a little proud be the first French recipient.

So it was that September that he headed to New York, aboard the Queen Elizabeth, which 'just reeks of all things English'. Second to France, England was the country with a lifestyle Christian most appreciated, saying, 'I love English customs, the sense of tradition, the politeness, the architecture', adding that he also enjoyed English cooking and found that 'eggs and bacon is an absolute delight'.

Having chosen to travel alone, Christian was nevertheless delighted to be drawn into the circle from *Vogue* magazine who were on the ship, including Bettina Ballard, but also, very usefully, Vogue's president, Iva Sergei Patcévitch.

Reminiscing later, Christian wrote about his experience in glowing terms; describing his first impressions of New York where everything was extravagant in scale and quality. He mentioned the city's imposing towers as expressions of 'the zest for life and self-confidence'. His enthusiasm carried him away, he said, making him forget France and the old continent. 'My Eiffel Tower and the lace-like beauty of its structure seems so very far away.'

He hadn't expected to be recognised upon arrival, or even to be expected at all, and certainly New York wasn't as excited to see the

RIGHT: 'Christian Dior receiving the 'Oscar for Couture' from Stanley Marcus, of the Neiman-Marcus specialty store in Dallas. September 8, 1947

'... dumpy little fellow with the balding head and dressed like an office clerk"

French couturier as he was to be there. Yet once the harsh rules of the game there became clear to him, Christian played them for all he was worth, professional that he was. His memories of his stay were peppered with incidents that might have come from the imagination of Jacques Tati, replete with lost luggage, misplaced papers and general bumbling happiness.

If Americans were expecting Christian to be the embodiment of Paris - perhaps through male glamour, a hint of arrogance paired with darling old-world charm - the '... dumpy little fellow with the balding head and dressed like an office clerk", hardly matched their expectations. Fortunately, his old friend, Nicolas Bongard, was on hand to help him survive the penetrating questions from the press, with the main worry on everybody's minds being, why did he wish to cover up women's legs? No self-respecting American could condone that.

Protestors considered the length of his dresses, coupled with the addition of padded hips and corseted waists, to be a serious assault on a woman's new-found freedoms and American culture. The menfolk stood foursquare behind their women too, because buying such wanton quantities of fabric was taxing their bank accounts. Men even formed their own organisation, the League of Broke Husbands. Christian found his every move shadowed by the malcontents. *Newsweek* weighed in as well, declaring that long skirts were dangerous. 'With today's speed, you can't even catch a streetcar in a long skirt. And how can you drive an auto?'

The news that his Neiman Marcus 'Oscar' fashion award would be presented to him in front of 3000 people, after which that he was expected to give a speech, caused Christian some anxiety. But spurred by panic and aided by genealogy, Christian decided to regale his audience with tales from his colourful past, so that 'when they called my name it was not I who got to my feet but a character from a game of charades'. He had the audience eating from the palm of his hand as they lapped up his tales of frivolity and nocturnal shenanigans with the artistic and celebrated names of Paris. From that point on, the gala receptions lost their fearsomeness, and he treated everyone to his memories of that colourful past.

Having come to understand the American game of celebrity, Christian honed his public appearances with the skill of a veteran. He rehearsed his gestures and facial expressions, and, with the questions often repeating themselves, he devised witty answers. He resolved to be amusing at all costs, realising that this was the key, and developed an adroitness in the abrupt about-turn if questions

GO WEST, MIDDLE-AGED FRENCHMAN!

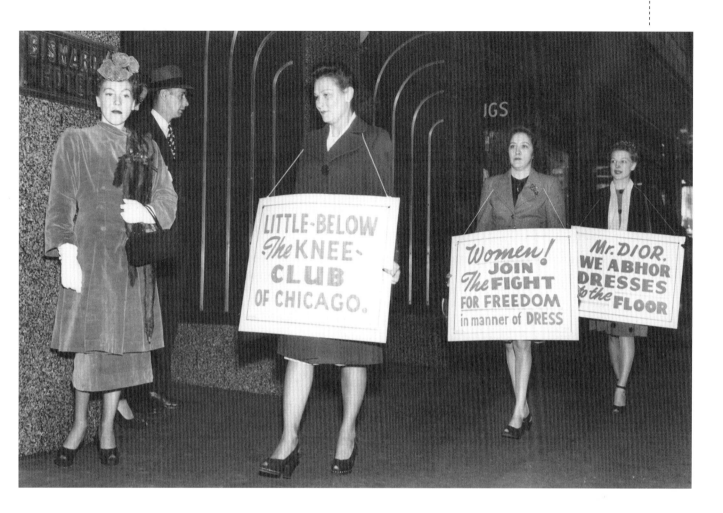

were heading in the wrong direction. He was unfailingly polite, listened intently, watched, and learned. He knew that there was one question he must never answer the wrong way; when asked if American women were the most beautiful, he inevitably replied, 'Yes'. And when he reminded audiences he was a self-made man, America adored this modest Frenchman even more. For his part, Christian was quite taken with the Americans and their ability to move between pleasure and business at the drop of a bon mot.

It didn't take long for Christian to realise that this wall-to-wall publicity, good or bad, was manna from heaven for his New Look. What he dubbed the 'Battle of the New Look', made Christian Dior more of a household name than ever before. All the big guns joined in on one side or the other; *Life* magazine, the *Wall Street Journal, Vogue* and *Harper's Bazaar*, of course. It was wonderful publicity.

The new fashion line was poured over as eagerly and intently as any army map, analysed and discussed in depth from every possible point of view. As the cold war clamped down on European

ABOVE: Women picket at Christian Dior's hotel, protesting his designs for long skirts, 22 September, 1947

freedoms, the greatest worry in the US was whether the skirt would remain high or low; that was the burning question on everybody's lips. Articles blossomed for weeks, as the newspapers and periodicals worked the story for every cent it was worth.

A survey indicated that most Americans favoured this New Look – a result that baffled everyone. A wartime law banning such opulence in clothing had just been repealed, which was good timing for Dior. And with Carmel Snow as his devoted advocate and unchallenged queen of US fashion taste, he could hardly fail. The most vivid exemplar of the sleek modern woman was to be found in progressive America, and yet here she was draping herself in long gloves, squeezing into whalebone corsets, slipping on yards of pearls and an entire circus tent of fabric.

For the American shops suffering from a lack of customers, there was only one thing to do: jump on the bandwagon in the hope that the interest generated by this Frenchman would spill over into the stores.

From Stanley Marcus's point of view, the controversy surrounding his latest 'Oscar' winner was just what he wanted, bringing celebrities to see the latest and the best that the fashion world had to offer. He was astute enough to

understand that Christian's New Look was a radical departure that would electrify an America in need of a fashion brush up. 'I have never seen anything so sensational', was his comment. It was a bonus for both men that Christian and Stanley enjoyed each other's company immediately. They expressed similar views on the need for courtesy and elegance in life, and Stanley was pleased to discover that his new friend was well versed in literature and art history. In the company of his

GO WEST, MIDDLE-AGED FRENCHMAN!

host, Christian was taken on a tour of New York's trendy neighbourhoods, although he also wished to see those where the less privileged spent their lives.

When it was time to return home, Christian justifiably looked upon his trip as a triumph, and the American fashion-selling machine wheeled into line behind their new favourite general. He was now, in the words of the chairman of the Bergdorf Goodman, 'unique'.

The interesting aftermath of his visit was that his autumn collection was adapted to suit American sensitivities; one example being the black wool crepe 'Margrave' cocktail dress, altered by designer Sophie Gimbel, which showed a wide décolletage with three bows on the fitted bodice. It was reproduced endless times, and changed its length as it dropped in price, to sport a zipper and nylon fabric, until it finally boomed as it became a cheap item for everywoman everywhere.

ABOVE: Wool crepe and silk velvet by Christian Dior; worn by ballerina Maria Tallchief, 1947

THE FASHION ICONS DIOR

THE GLOSS TURNS GLOBAL 1948-1953

"Simplicity, good taste, and grooming are the three fundamentals of good dressing and these do not cost money."

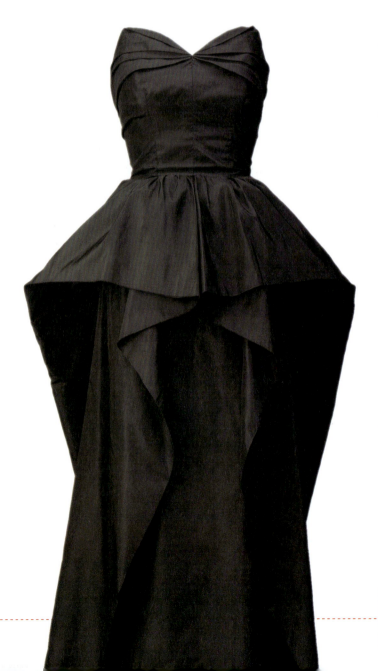

1948 saw Dior back in New York to establish a shop on Fifth Avenue. The new premises were at number 730, but he set up shop in a rented building on 62nd Street, where he brought his team to fill the workrooms and the models' dressing room beside his own studio.

The first showing took place on 8 November and produced another best-selling item for the couturier, a peplum jacket called 'Bobby'; named after Christian's dog. The show opened Christian's eyes to the fact that fashion could remain consistently popular over a long period of time, the 'Bobby' jacket remaining a best-seller for eight seasons. From then on, Christian Dior would make two trips a year to the American capital to design his collections, which were bought by Saks, Bergdorf and many other stores.

His 5th Avenue premises became a showroom rather than a sales outlet, and although most

RIGHT: Christian Dior at a cafe with his dog Bobby
LEFT: Evening dress, Silk taffeta, 1948

THE FASHION ICONS DIOR

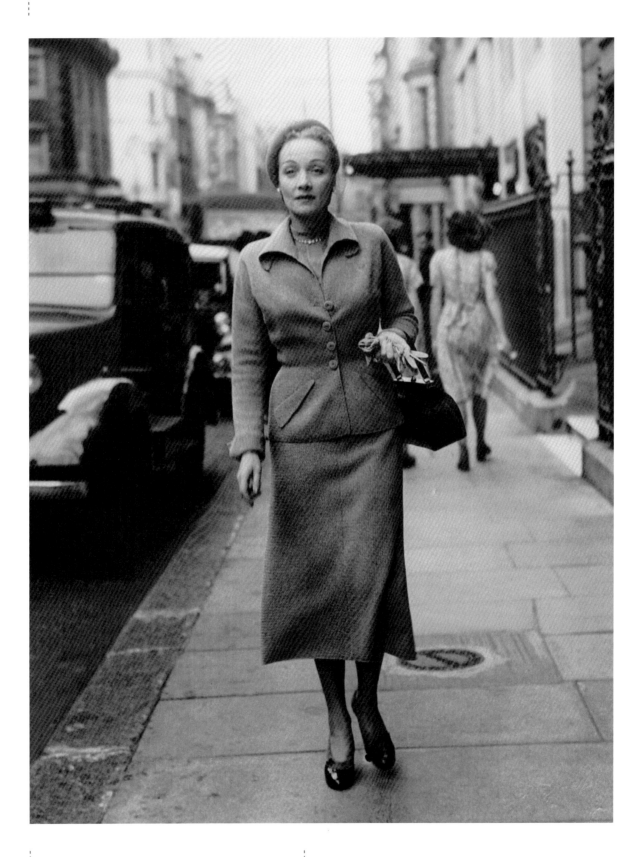

ABOVE: Marlene Dietrich, in a grey wool Christian Dior suit, outside the Claridge Hotel in London, June 1949

THE GLOSS TURNS GLOBAL

87

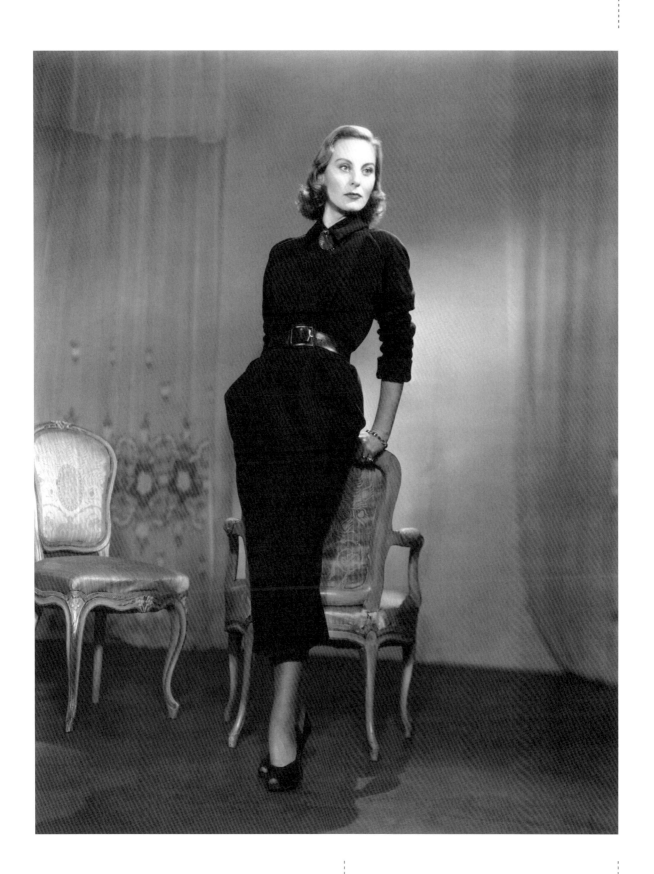

ABOVE: Michèle Morgan, modeling a black wool dress by Christian Dior, 1949

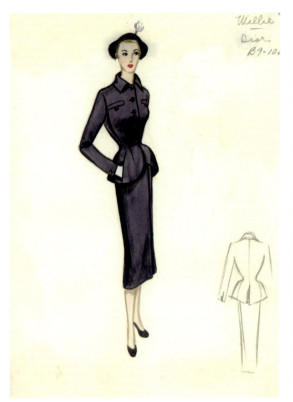
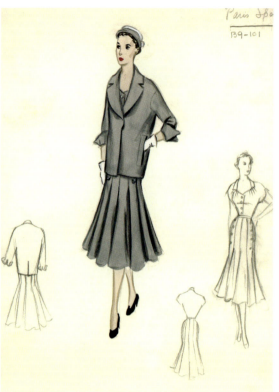
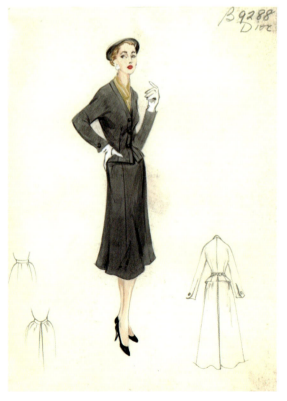
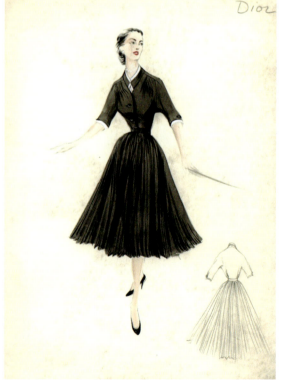

ABOVE & RIGHT: A selection of Christian Dior designs during 1950 - 1952

THE GLOSS TURNS GLOBAL

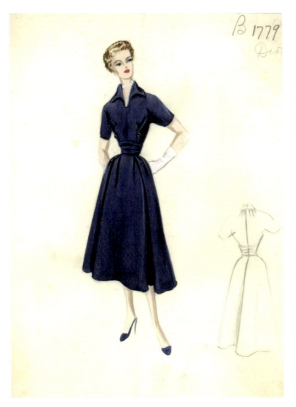
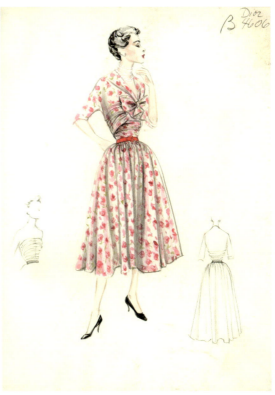
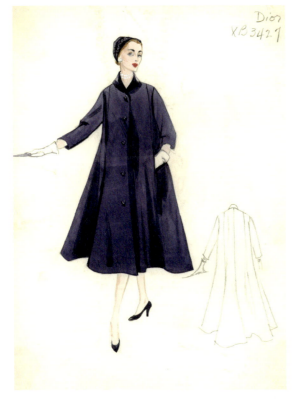
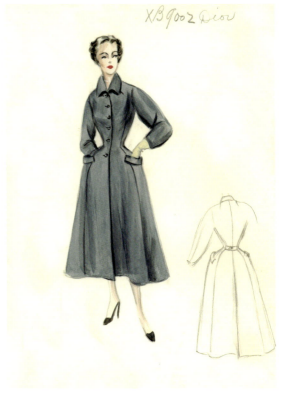

of his collection was made in the 5th Avenue workrooms, selected American manufacturers would also produce his clothes. He astutely used the smoothly run American distribution system to his benefit to spread the gospel according to Dior, whilst keeping the couturier mystique, and retaining control of his company. It was a clever juggling act. His contacts also enabled him to manage the constant ebb and flow of American fashions requirements; and control, as best he could, the unwanted unauthorised reworking of his designs to bring down the prices for a mass market.

This led his associate Jacques Rouët to develop a new marketing strategy. By pioneering licensing deals, he ensured that Christian Dior's name became prominent on luxury items such as furs, ties, handbags, shoes, scarves, and jewellery. As well as generating additional income, the licensing agreements made Dior a household name.

Christian embraced this business model with both hands; if the House of Dior opened a presence in another country, that country would be honoured with a dress to celebrate it. When he renewed contracts, he cannily insisted that a percentage of the turnover would be the price of renewal, replacing a one-off fee, and he also insisted on controlling the quality.

THE GLOSS TURNS GLOBAL

Christian also brought the first Dior hosiery products onto the market in 1949. He came up with a reinforced foot to prevent slippage and presented his designs in elegant boxes to compete with Schiaparelli's shocking pink versions.

As these licensing deals proliferated, Christian kept a close eye on the whole process, taking royalties of 30 to 40 per cent.

Some of his fellow couturiers watched with envious dissatisfaction and accused him of flying in the face of tradition. Backed by the French press, who loved controversy as much as the American journalists, they opined that he was 'signing the death knell of a craft that is centuries old'. Nonetheless, the licensing deal has since deeply embedded itself in the fashion industry.

In 1956, the house of Dior even registered a spirits and wines trademark; but this was not pursued after 1962. In 1972, Jacques finally gave into an idea that Christian had had many years before of entering the food market and published a book of Christian's recipes; 'La Cuisine cousu main' or 'Hand-stitched Cuisine'.

ABOVE: 1950s Dior hosiery advert and La Cuisine cousu-main book cover
LEFT: Model wearing a Dior suit, 1951

92 THE FASHION ICONS DIOR

ABOVE & RIGHT: A model opens her silk coat for an audience at a Christian Dior show, 7th June 1952

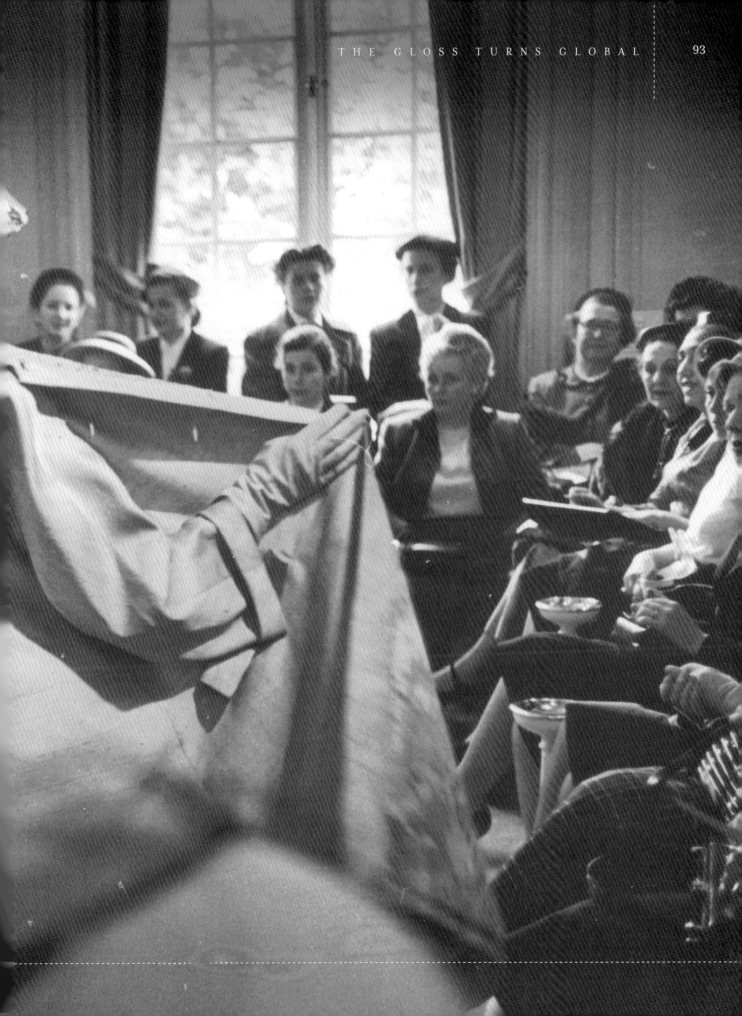

PRÊT-À-DIOR 1952-1953

"They are my daydreams, but they have passed from dreamland into the world of everyday items to wear."

With his staff levels now around the 900 mark, Dior opened his London store in 1952 in Mayfair. But at the same time, the New York premises were closed, because the cost of bringing the whole team over twice a year was proving too prohibitive. It was decided that the collections would be designed and prepared in Paris instead, with the finished products then shipped to the United States. It was cheaper to bring over his American models and carry out the fittings in Paris; these American models, by the way, were all given names beginning with Christian's lucky letter M, as in Maple, Marcia, Mary, and Marjorie.

Meanwhile, Jacques arranged further licensing deals in Canada, Mexico, Chile, and Cuba, having hit upon a brilliant new way to market the clothes. The idea was, that as the clothes were being copied anyway, the company could permit buyers to also spend a 60,000 deposit for a 'toile' – a replica pattern. They would also be provided with details of the original fabrics and all the trimmings, plus the

legal entitlement to affix a Dior label to the finished clothing. There was also a simple paper pattern available, which enabled the manufacturer to make his own decisions about colours and fabrics, and a copyright on the designs. This method proved to be highly profitable for the House of Dior.

Despite the aggravation of illegal copying of his designs, at which the Americans were past masters, his enterprise went from strength to strength. A whole swathe of new companies joined his roster: Christian Dior Perfumes was launched in New York in 1948, with Christian Dior stockings and the Diorama fragrance following a year later.

RIGHT: Christian Dior at work in his Paris studio, on a coat made from English silks by Seeker
ABOVE: Early 1950s Dior silk tie

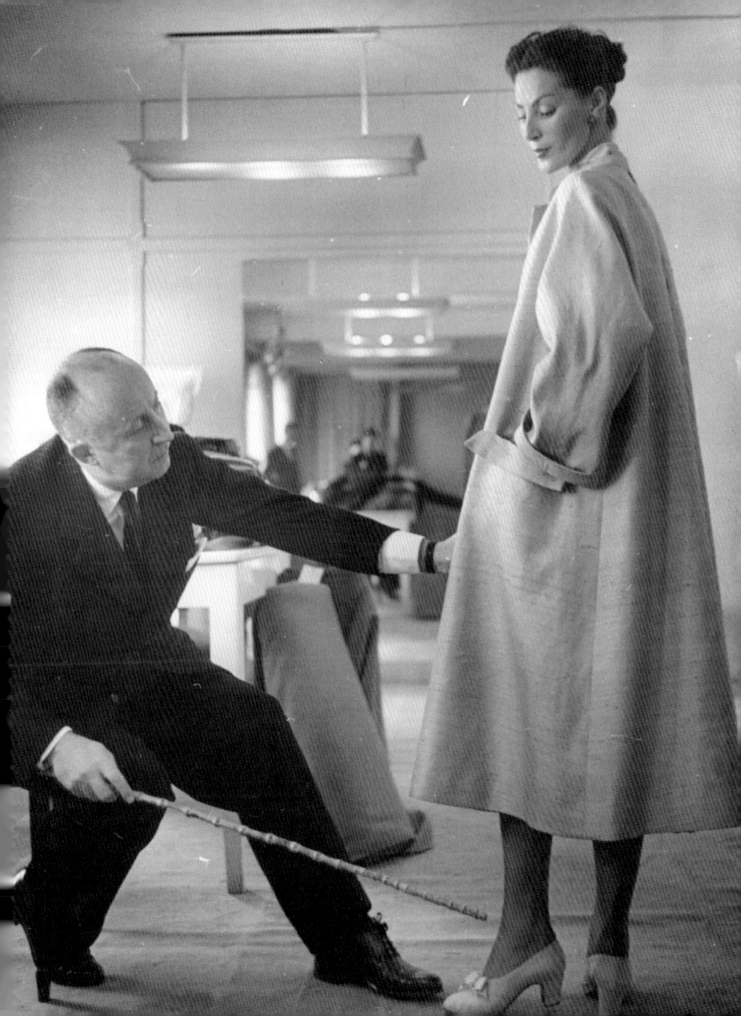

THE FASHION ICONS DIOR

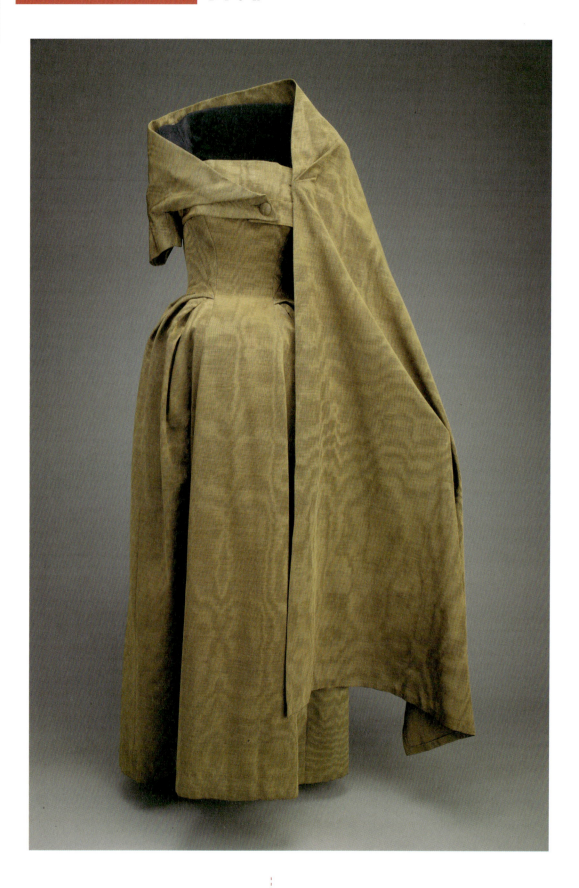

ABOVE: 1953 Evening dress and stole, Ribbed silk moiré by Christian Dior

PRÊT-À-DIOR 97

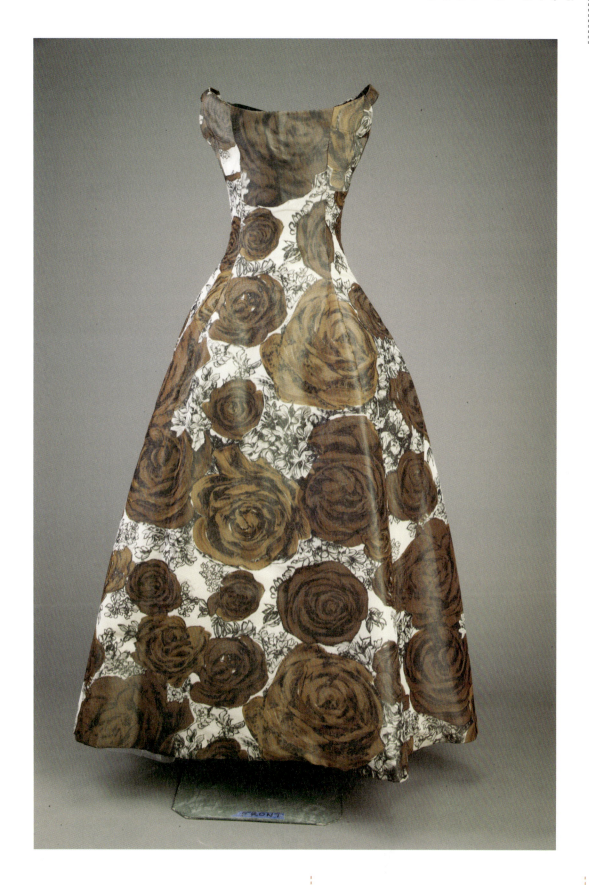

ABOVE: 1953 Silk taffeta by Christian Dior; worn by dancer and choreographer Ruth Page

Christian Dior ties and cravats were hot on their heels in 1950, together with a Christian Dior Diffusion department and Christian Dior Fur Inc. There was also a Christian Dior Export Corporation, and in 1952, London saw Christian Dior models Ltd. All this took the Americans by surprise, as they prided themselves on being at the forefront of progress in all fields. Dior would also make the winning concept of prêt-à-porter reap rich rewards.

Christian's publicity team was second to none, and every collection that he brought out would be on the cover of *Vogue, Bazaar, Time, Match* or *Elle*. Insistence on quality, and of treating every client as though they were the only one, was paying handsome dividends.

To be taken under the wing of Christian Dior was to find the golden chalice of fashion, and a rare thing indeed. The shoe designer Roger Vivier succeeded after several attempts, and his shoes would then be resplendently displayed amidst layers of fabric at Avenue Montaigne and grace the feet of models when the collections were shown. Vivier's name was never shown, even on the labels; Christian Dior was to be omnipresent and dominant in all things fashion. The admission of Roger Vivier into his stable, brought Christian's dream of being able to clothe a woman in his designs from head to toe to fruition, and the place for a woman to go for this transformation would be the boutique he opened in 1955 in Rue François-Ier. There, his clients could browse to their hearts' content through a whole range of scarves, jerseys, shorts, pullovers, cloth bags for suitcases, summer dresses at reasonable prices, belts, and a plethora of gifts – and then visit Roger's shoe shop next door.

Following the principal that you cannot have too much of a good thing, Christian caused uproar again in 1953 when he created what the press dubbed 'the battle of the bare calf'. Now nicknamed, 'tyrant of the hemlines', Christian raised the hems of his designs, having learned that Americans loved this kind of hype, because it helped to sell anything. He employed this publicity gimmick effectively to keep the press and fashion police at boiling point constantly, to his own advantage.

He heaped on the agony by bringing out the H-line in 1954. Christened 'the Flat Look' by Carmel Snow, the idea that this audacious Frenchman trying to make the proud American female bosom disappear caused uproar.

'Dior will never crush US womanhood', trumpeted the press indignantly; Christian must have laughed all the way to the bank.

RIGHT: Roger Vivier, 1953

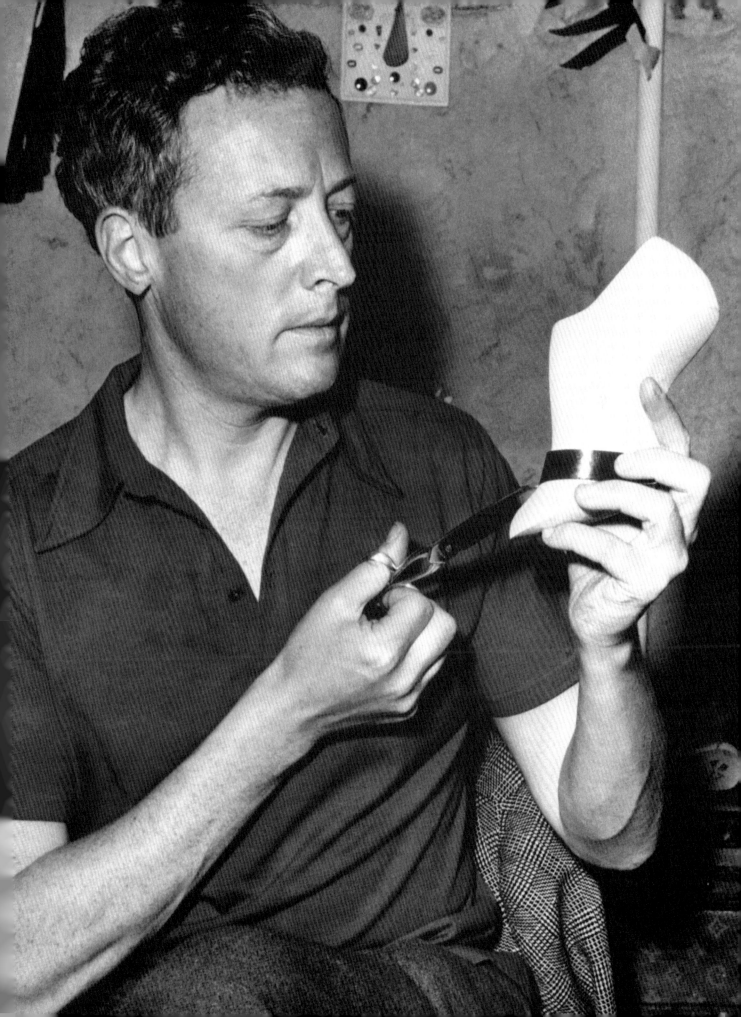

THE FASHION ICONS DIOR

THIS TERRIBLE, WONDERFUL PUBLIC 1954-1957

"Finally, everything that has been part of my life, whether I wanted it to or not, has expressed itself in my dresses."

Christian Dior's collections flowed out now, bearing descriptions that would enable the public – and the press - to remember them. The 1953 spring collection, for example, , was a proliferation of flowery prints and floating fabrics true to its name of Tulipe .

The programme notes were written by Christian himself, leaving nothing to chance and suggesting accessories to fit his new acolytes, with buyers individually informed about the fabrics to be used, the linings and so on.

Aware that America adored sensationalism, Christian trod a fine line between satisfying the more sensitive appreciation of his Parisian clientele, while presenting a collection that would captivate an audience of 2,000 people in a mega show in the US. After all he needed the necessary pizzazz that would enable him to retain the name King Barnum of fashion, given to him by America's *Time* magazine.

And the fashion world lapped up each of Dior's offerings, which would sometimes introduce two lines in one showing. For example 1948 brought in the Envol line, where hemlines sloped down at the back in an imitation of wings, and the Cyclone line with its reinvented width. The Zigzag line also came out this year.

1949 welcomed the Trompe l'Oeil and Mid-Century lines, whilst in 1950 the newspaper and magazine articles were alight with descriptions of the Vertical and Oblique lines. The Naturelle/Princesse and Longue lines were unleashed in 1951 with the Sinueuse and Profilée lines in 1952, the Tulipe and its autumn Vivante line in 1953. The Vivante line featured the renowned Aladdin dress that Dior

RIGHT: Christian Dior, circa 1956

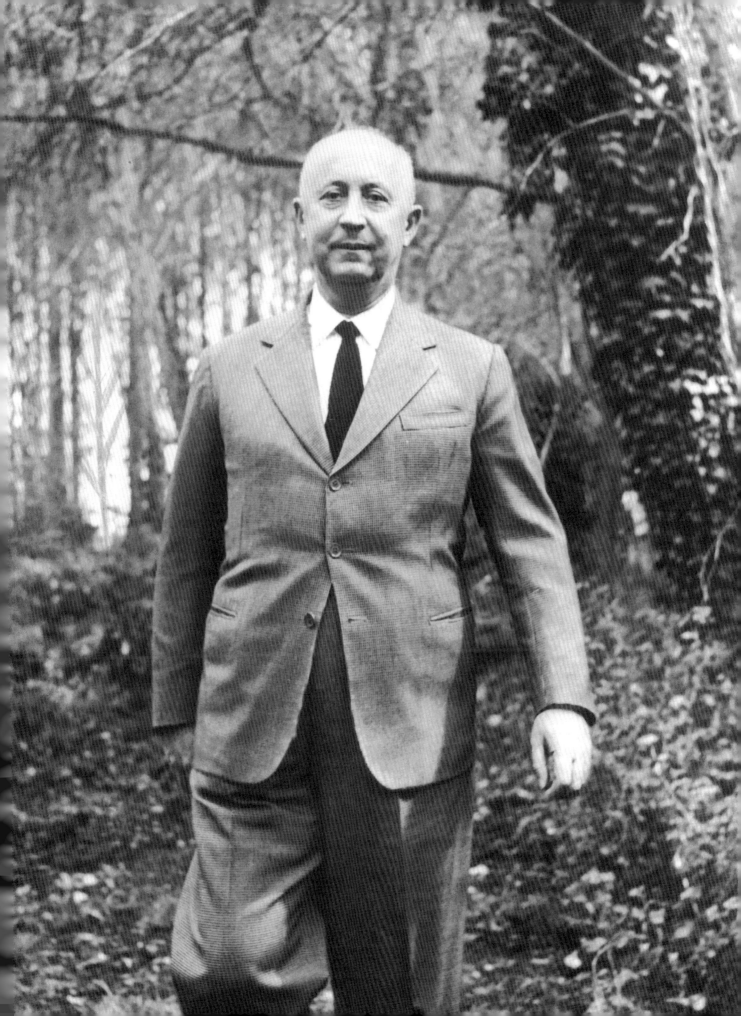

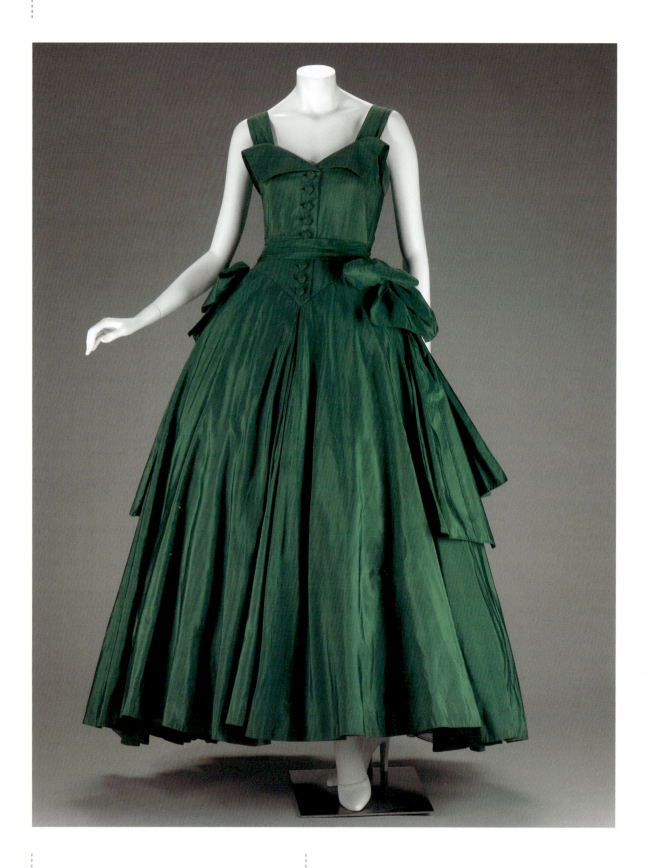

ABOVE: Green evening dress by Christian Dior, 1954

THIS TERRIBLE, WONDERFUL PUBLIC

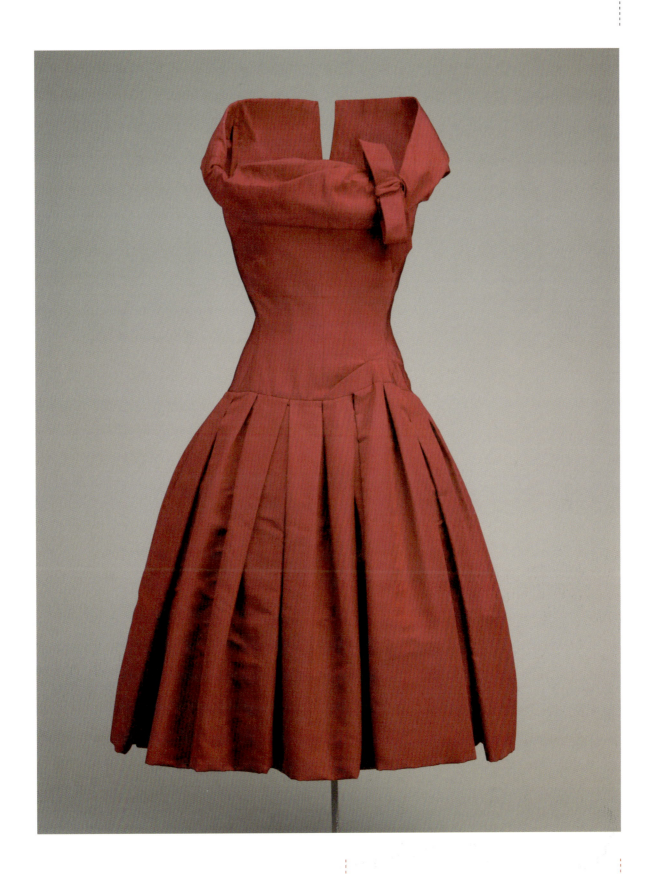

ABOVE: Cocktail dress, Silk taffeta by Christian Dior; worn by dancer and choreographer Ruth Page, 1954

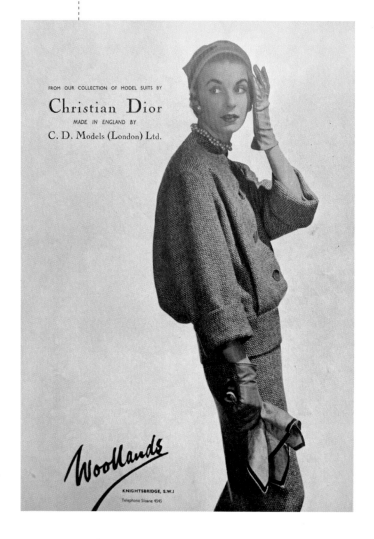

designed himself. Its silk cocktail gown increases in volume as it descends from the waist and perfectly embodies the silhouette of Dior's New Look.

Often looking to geometry for inspiration, the Muguet line and H-Line graced the 1954 female figure; the H-Line focussed on a silhouette shape, and – as the letter 'H' implies– it was straight, with the waist slightly accented to produce the bar of the letter H. It became popular for emphasising the length of the leg, spotlighting its feminine form. Zemire was a pink satin evening suit that emerged from this autumn-winter collection.

The A-Line and Y-Line arrived in 1955. The "A-line" allowed the waist to remain undefined that season, providing a smooth silhouette that would flow generously over the hips and legs, and as the name indicated, resembled a capital A. This was the year that Christian hired a young designer to assist in the workshops, who would go on to greater fame in the same way that Dior and Balmain had done; he was the 19-year-old Yves Saint Laurent.

Dior's introduction of his 'Flat Look' in 1954 took the fashion world completely by surprise. Practically overnight, the New Look had been consigned to the wastepaper basket as Christian attempted to make an adolescent image fashionable. Ironically, Christian was harking back to the 'war' that he had fought in the past against the 'gamin' look advocated by the likes of Chanel. No matter. All's fair in love and couture.

Chanel, incidentally, had re-entered the fray in 1953, and become a serious competitor. Christian took note, and without fuss did a swift and unexplained volte-face, perhaps before he was swept along in the tide anyway. After all, the fashion world had learned from his pioneering ways and his colleagues were on his tail with their own prêt-à-porter.

RIGHT: Christian Dior standing in a showroom with samples of his hats, hat pins, gloves, muffs, lingerie, hosiery, evening bags, and jewellery, 1955

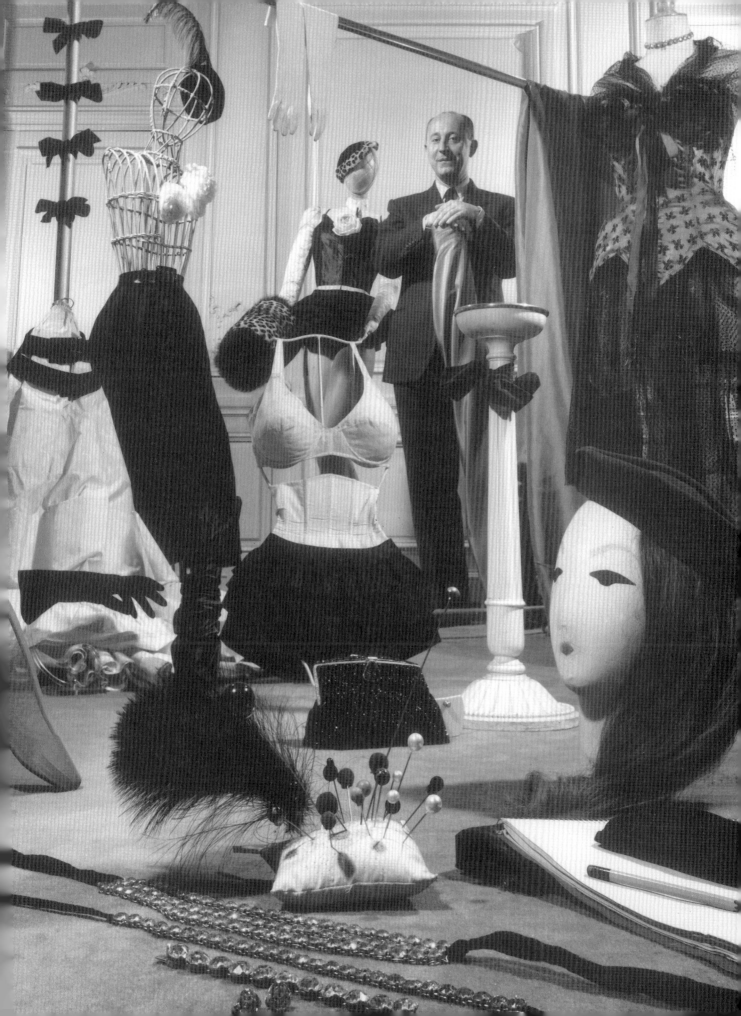

By 1956, it was the turn of the Flèche and the Aimant lines, and, in what transpired to be the last he would ever create himself, 1957 saw the Libre and Fuseau lines.

Christian's designs would occasionally hark back to Second Empire, or the historical styles that he loved so much, whilst in other collections he would create trompe-l'oeil detailing, and juxtapose soft and hard looks for menswear, integrating them into modern wardrobes.

So by 1957, he was investigating the possibilities of a more fluid silhouette that would mesh with modern lifestyles, designing chemises, narrow tunics, and wraps that echoed saris.

Which collection was the master's favourite? This honour was accorded to the 1951 autumn-winter collection, which contained one of his evergreen creations, the black wool dress, and the little grey dress made of flannel. In keeping with so many of his designs, the black wool dress, this 'second skin', was simple and yet inventive and delighted his clients, as did a myriad of his designs such as his mink coat with detachable layers, the flannel cocktail suit and the off-the-shoulder dress descending to calf length. The pleated skirt that Dior made famous, obviated the need for a split skirt that, in his opinion, would ruin the line as it parted over the calf. Skirts were lined with taffeta with a wide band edging them.

With the demise of the New Look, the era upon which Christian Dior had stamped his name and his vision came to an end. His astonishing rise to couture stardom, raised the general public's appreciation of other couturiers, who then benefited with both improved status and financial rewards.

RIGHT: Cocktail dress, Silk taffeta, Silk organza by Christian Dior, Spring 1956 collection entitled the 'Tulip' line'

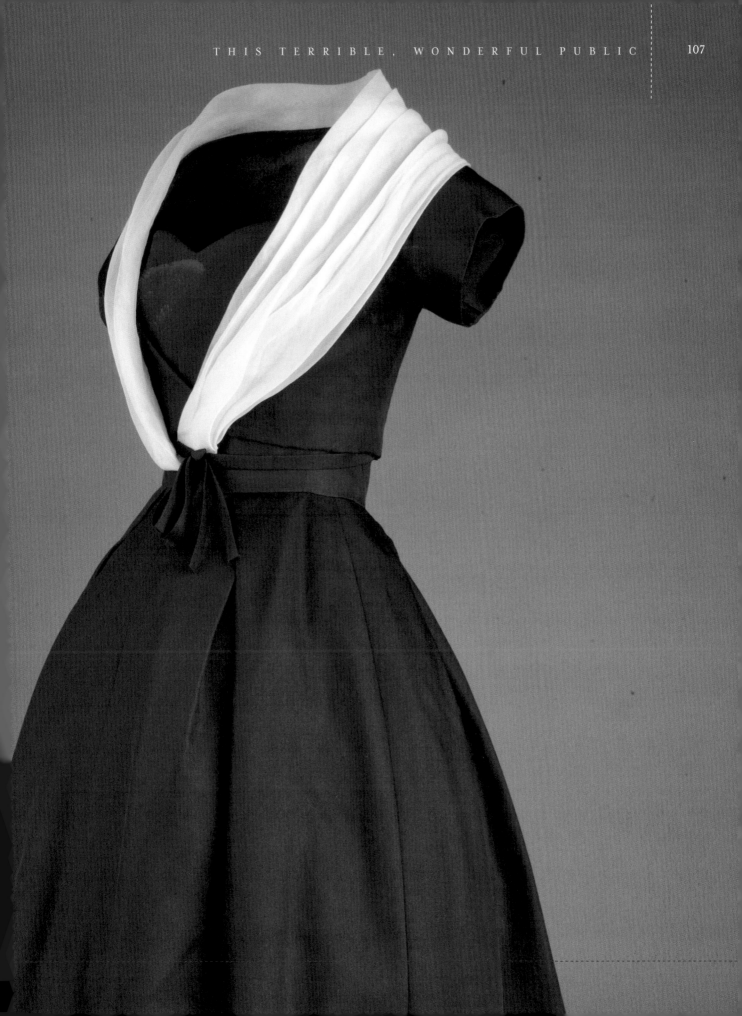

THE FASHION ICONS DIOR

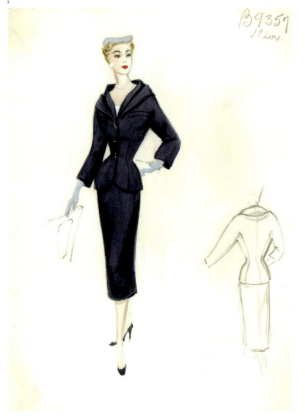
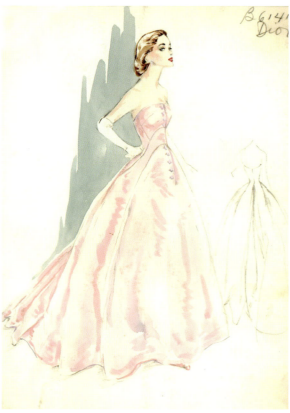
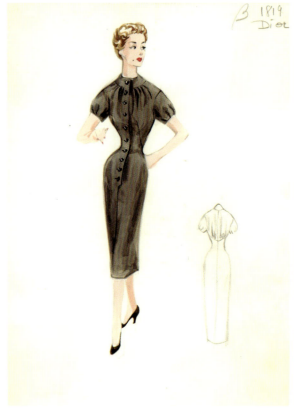
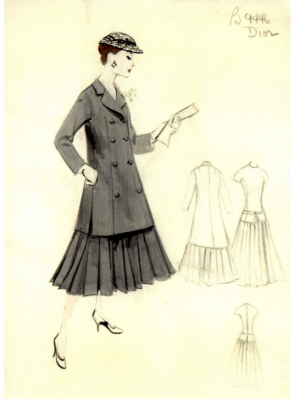

ABOVE & RIGHT: A selection of Christian Dior designs during 1953 - 1956

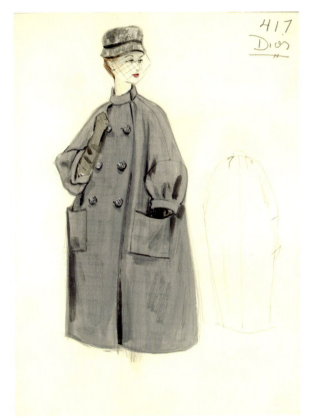
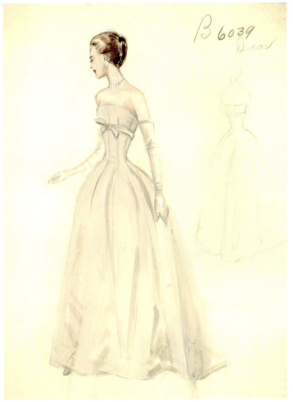
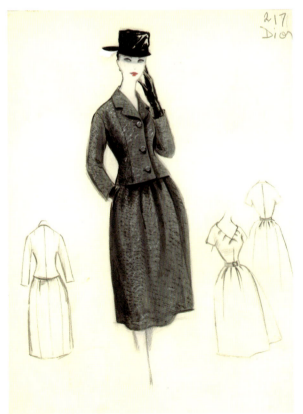
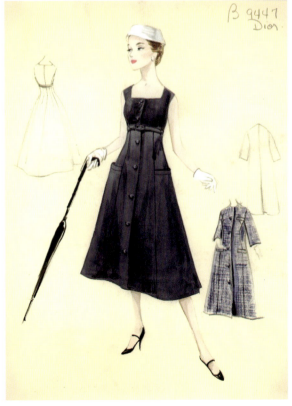

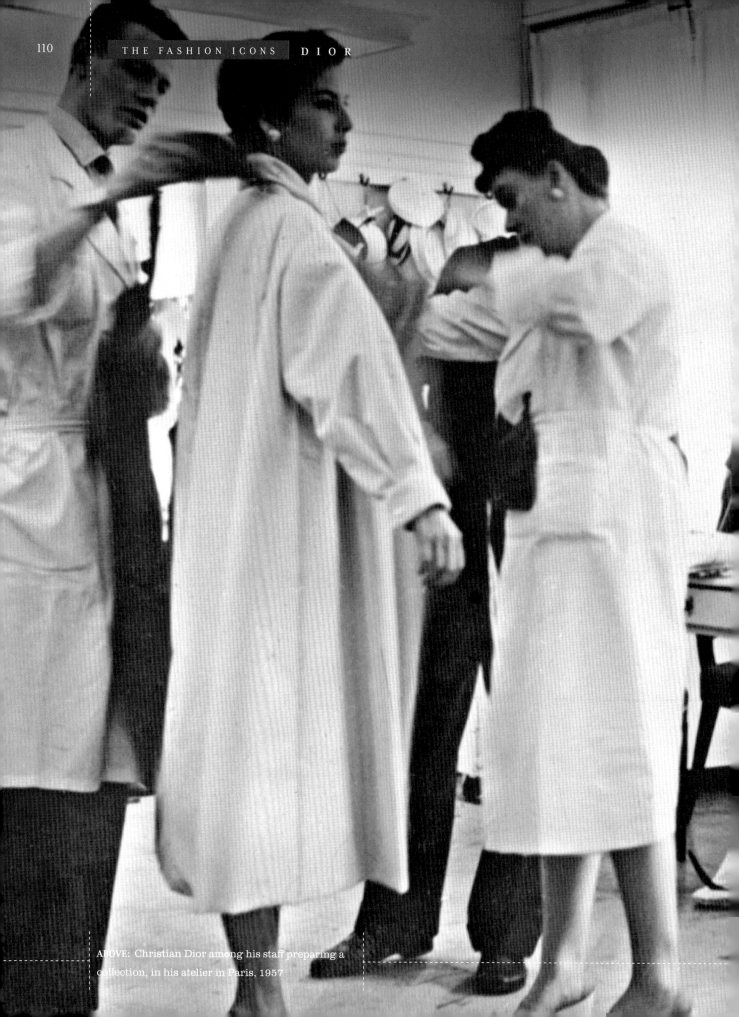

ABOVE: Christian Dior among his staff preparing a collection, in his atelier in Paris, 1957

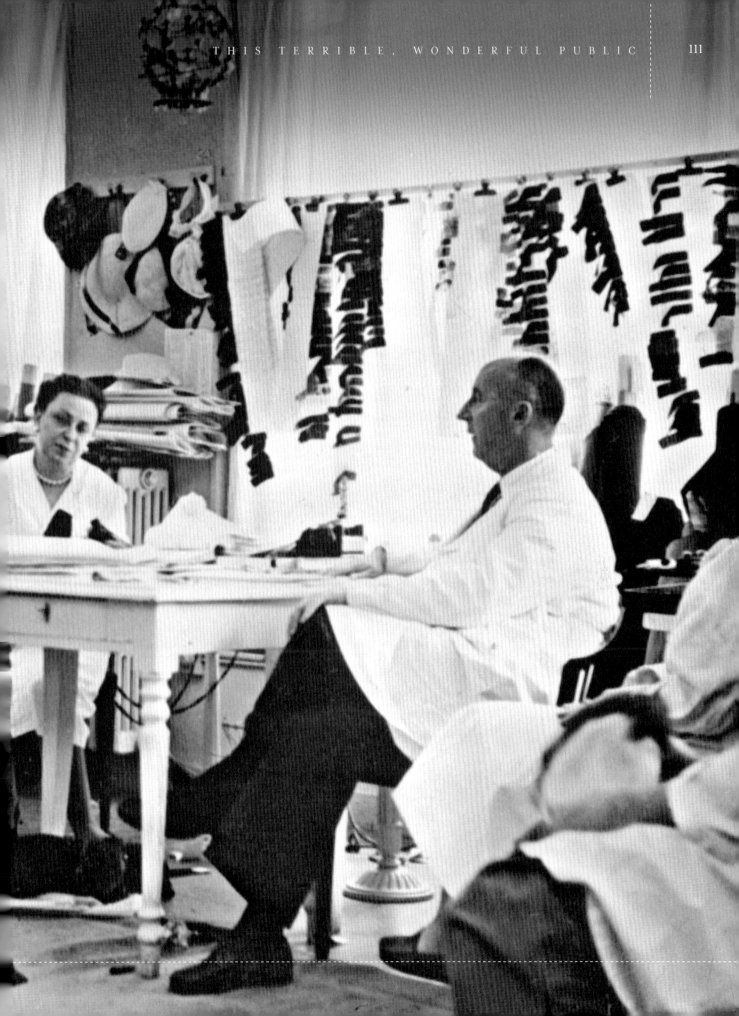

THE FASHION ICONS DIOR

THIS TERRIBLE, WONDERFUL PUBLIC 113

ABOVE: Christian Dior preparing a new collection in his workshops, in which we can see seamstresses busying themselves around a tulle dress. Christian forbids the photographer to enter, with a wave of his hand, 1957

THOSE WHOM THE GODS LOVE 1957

"Deep in every heart slumbers a dream and the couturier knows it: every woman is a princess."

The Dior business machine developed into a formidable steamroller, and as the progenitor of the whole enterprise, Christian was careful to project a beneficent image of himself smiling at the top of the pyramid, a fatherly eye upon his flock. He knew, and relished the fact, that his employees were terrified of him, using that information to push them to achieve the perfection he wanted. His dictatorial manner was second to none when it was time to show his collections. Employees would work phenomenal hours, barely able to return home to snatch a few hours of sleep; yet wealthy as he was, Christian Dior would never dream of rewarding staff with overtime payments. Once the event was over, his staff might console themselves with a rare crumb of praise from the mighty couturier. Perhaps he was not quite the avuncular figure the world was led to believe.

Avoiding the press

All the manic press activity did nothing to entice Christian to face the flashlights himself. Even his public relations department could barely pin him down to give an interview, and when he did he was awkward and shy, reverting to his tried and tested method of turning the horrid questions into humorous answers. His pièce de résistance in avoidance tactics was to agree to interviews, but with conditions – if they could do the session 'in Portuguese?' for example. Or with him naked in the bathtub, as did once happen. There is even a photograph to prove it.

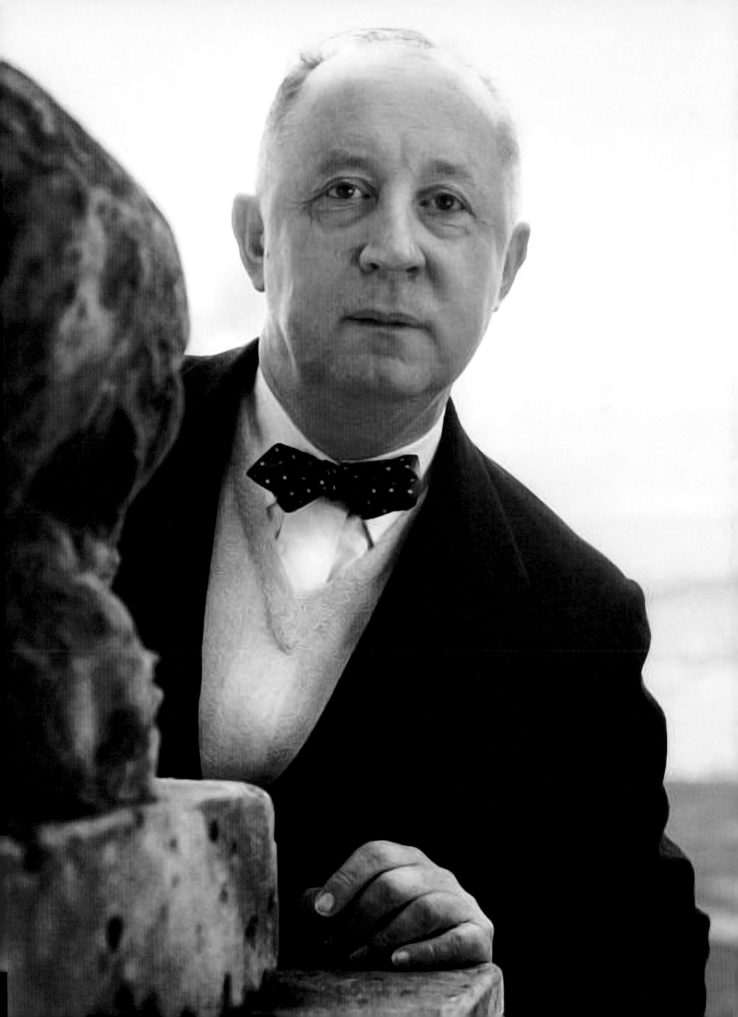

Dior's enormous ego needed everyone to know that he was the greatest couturier who had ever lived, as he himself believed. Anything less than unadorned admiration of him would not do.

The need to remain at the top led to what some believed was an unnecessary urge to change for the sake of change. He had started a treadmill that he could no longer control and was in fact now enslaved by.

Raymonde Zehnacker, the head of his workshop, had become indispensable, not just professionally, but now personally as well. She was always there when he needed her, day or night, to pander to him, chide him, rescue him, and even get him to sleep. She alone could mention the fact that he was putting on weight, she alone was the keeper of the diary, and the one who ushered in the young men for Christian's lonely nights. She became the centre of his world and had her own room in each of his houses. His need for her presence, and hers for his, was insatiable.

But even she couldn't fill that little part of him that needed more personal love. But eventually, in 1956, Christian found love in the form of a young Moroccan man named Jacques Benita. A singer born into a Sephardic Jewish family, now trying to make his way in Paris, Jacques had been raised without a father and was attracted to older men. At 27 years old, he, like Christian, suffered from extreme shyness. They met at Milly-la-Forêt, when Jacques had accompanied the photographer André Ostier, on a visit to take Christian's portrait at his home.

Jacques faced an uphill struggle to maintain his relationship with Christian. He wasn't part of the fashion scene and Raymonde disparaged him as the one who 'takes the metro'. But she ultimately lost the battle.

Catherine Dior would later recall that she had never seen her brother as happy as he was during his time with Jacques. Christian finally felt normal again, when he and Jacques could simply watch a film in a cinema. Christian was genuinely in love and could not bear to be without his new friend. Jacques would often accompany Christian to dinner with Salvador Dalí and his wife Gala in Barcelona.

But despite enjoying some personal happiness at last, on top of his many professional achievements, Christian found the pressure of maintaining his success almost unbearable, particularly as his new shows approached. Raymonde was used to desperate calls from Christian in the dead of night, as he sobbed his heart out to her; used to soothing him and sending him back into bed, ensuring that no one knew what was happening in her employer's head.

LEFT: Christian Dior, working on his last collection, 1957

Christian loved fine dining - foie gras and candied fruit were favourites - and his girth expanded accordingly. In the restaurant of the Hotel Plaza Athénée, which was conveniently sited opposite the company headquarters, lobster and lamb chops from Lozère would be followed by a Norwegian omelette with raspberries and vanilla. It was a menu that no doubt contributed to Christian's first heart attack in 1947. Only his chauffeur, Pierre Perritoni, had been a witness to that. Doctors had issued warnings about kidney problems and the necessity for a change in lifestyle, to no avail. Christian was a workaholic. He preferred to rely on his lucky charms; the sprig of lily-of-the-valley, a four-leaf clover, a piece of engraved gold, a little piece of wood and his famous gilt star. And, of course, Madame Delahaye the fortune-teller, who would have to choose the correct date for a collection to be shown.

High standards

Christian's desire for perfection, which set his employees both in his workshops and in his house trembling, prevented him from ever being gentle with himself or those around him. No dust dare settle on his silverware, no lamp prove defective, no piece of furniture depart from its allotted position. 'The rules of good taste do not matter since they must, in my home, give way to those of my own taste', he once declared.

The house in which he spent the last years of his life, was subjected to exactly these rigorous standards. The private mansion in Paris at No. 7, Boulevard Jules-Sandeau was acquired in 1950. Its small living room was connected to the dining room where breakfast would be served, unless he took it in bed on a tray. But then, there might be a second breakfast. Bouquets of fresh flowers graced the rooms where he would entertain those invited to the dinners and social receptions he organised regularly.

RIGHT: Dior studio getting ready for Christian Dior's last collection, 1957

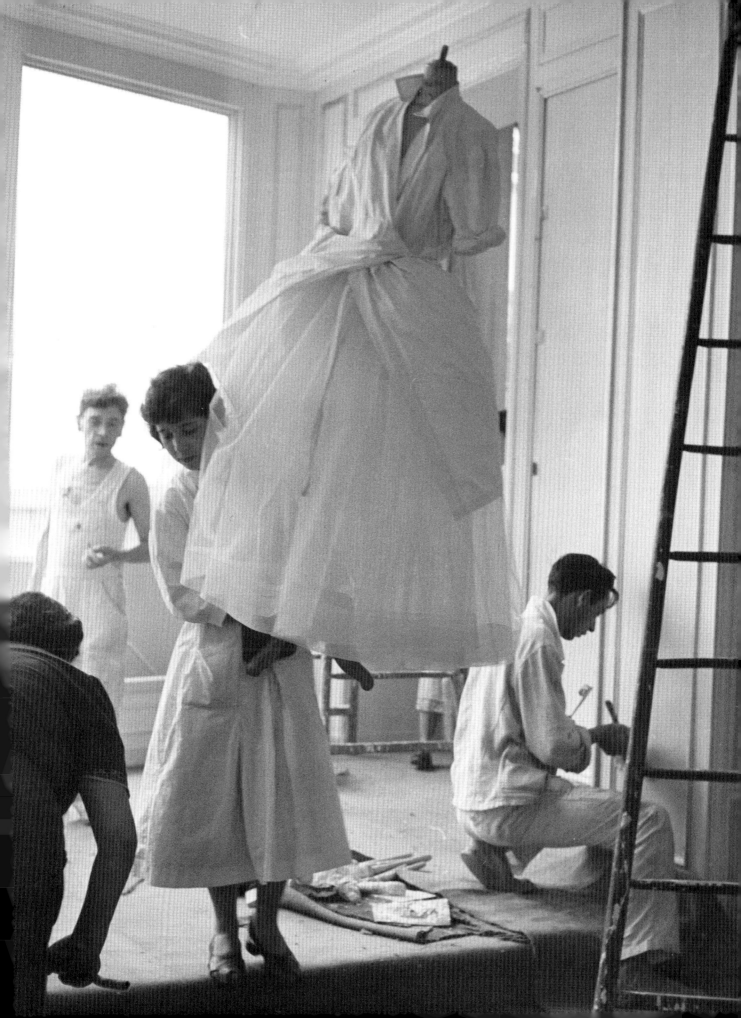

THE FASHION ICONS | **DIOR**

ABOVE: The day after the death of Christian Dior. Paris, October 1947. The studio deserted after the last collection

What no one except his secretaries knew was that Christian's extravagant lifestyle meant that his vast wealth had evaporated by 1957. Worse, he had also accumulated a debt of 40 million francs. His insatiable desire for new and better meant that his houses became bottomless pits where money went to die. He knew that he should rein in his desires but was incapable of changing his ways.

The autumn collection, the 'Spindle' line, took everyone by surprise again, featuring a loose fit with 'relaxed and casual elegance' and showing no waistline. It was unflatteringly dubbed the 'sack dress'.

Having suffered from extreme exhaustion after the October fashion show; Christian decided that he needed to rest urgently. So he decided to take a 'cure' at a resort with thermal baths in Tuscany, Italy, where he would try to lose weight and improve his health, especially his liver. Madame Delahaye found negative readings in his cards and tried to persuade him to jettison his travel plans. Jacques did likewise; to no avail.

The evening before he was due to leave, Christian threw a party for some of his closest friends. The next day, he boarded a train to the spa town of Montecatini. It was there, on 24 October 1957, that he suffered a fatal heart attack - apparently while playing cards with Raymonde, his chauffeur Pierre and his goddaughter.

He was 52 years of age.

Jacques Benita, never absorbed into the selfishly jealous circle of women around Christian, was accused of hastening his death by wanting his lover to lose weight, a false accusation and one he vigorously denied. Jacques left for America and cut his association with the Dior world, returning to Paris later as Tony Sandro.

Christian's body was flown back from Italy and the funeral service held in the church of Saint Honoré d'Eylau in Paris. The pews were filled with his employees, famous names from haute couture such as Balmain, Givenchy, Cardin, and Balenciaga, sitting alongside well-known names from every other walk of life, from Jean Cocteau to the Duchess of Windsor. In all 2,500 people came to bid farewell.

After the service, the hearse, bearing its coffin of Italian oak, was driven down to Provence and the little village of Callian that Christian had chosen for his last resting place.

The short but glowing life of Christian Dior was over.

Further departures

Christian's brother Bernard, died in 1960 at the age of 50, having never been released from his incarceration.

His elder brother Raymond died in 1996 and his sister Jacqueline died in 2002. His favourite sister Catherine died in 2008 aged 90.

His lover Jacques Benita died in Paris in 2021 at the age of 91.

Jacques Rouët, the close associate who ensured Christian's business flourished and his reputation remained unblemished, remained with the House of Dior for another 30 years after Christian's death.

RIGHT: Funeral of Christian Dior, 1957

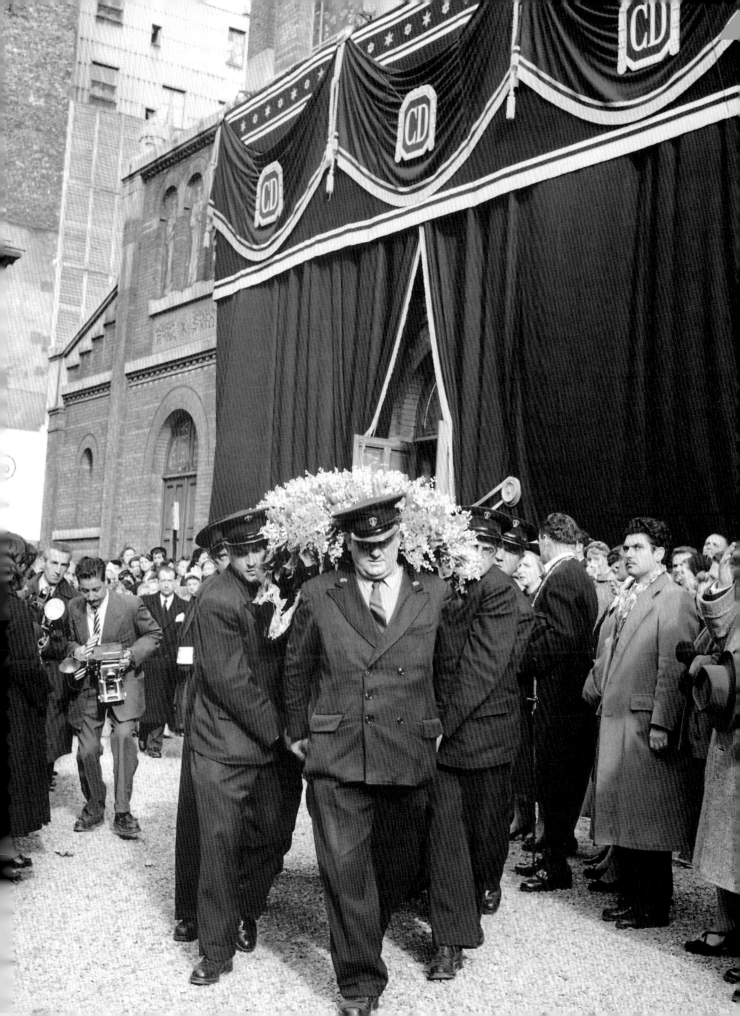

EPILOGUE

"I wanted to be considered a good craftsman. I wanted my dresses to be constructed like buildings, moulded to the curves of the female form, stylising its shape."

Christian Dior was an artist who morphed into a businessman throwing the fashion world off balance with his designs, in keeping with his quixotic nature.

His styles outlived their creator, and film brought them to new audiences worldwide.

It is true to say that Christian Dior revitalised and revolutionised the fashion industry. He not only changed the way that women looked and viewed themselves, with astute stratagems and creative innovation, he exploited his publicity value and stayed ahead of the pack by introducing seasonal changes. In 1950, over half the total profits earned by the Parisian couture industry came from Maison Dior.

Although he designed under his own name for a mere 10 years, his influence is vast. The fashion house created by Christian Dior back in 1947 has stood the test of time and continues to flourish. Today the business is owned by Bernard Arnault, the French billionaire behind LVMH Moët Hennessy Louis Vuitton. As part of LVMH, Christian Dior continues to be a successful standalone brand.

The designs themselves have changed in line with the talents of the six successors who have headed the business up since 1957.

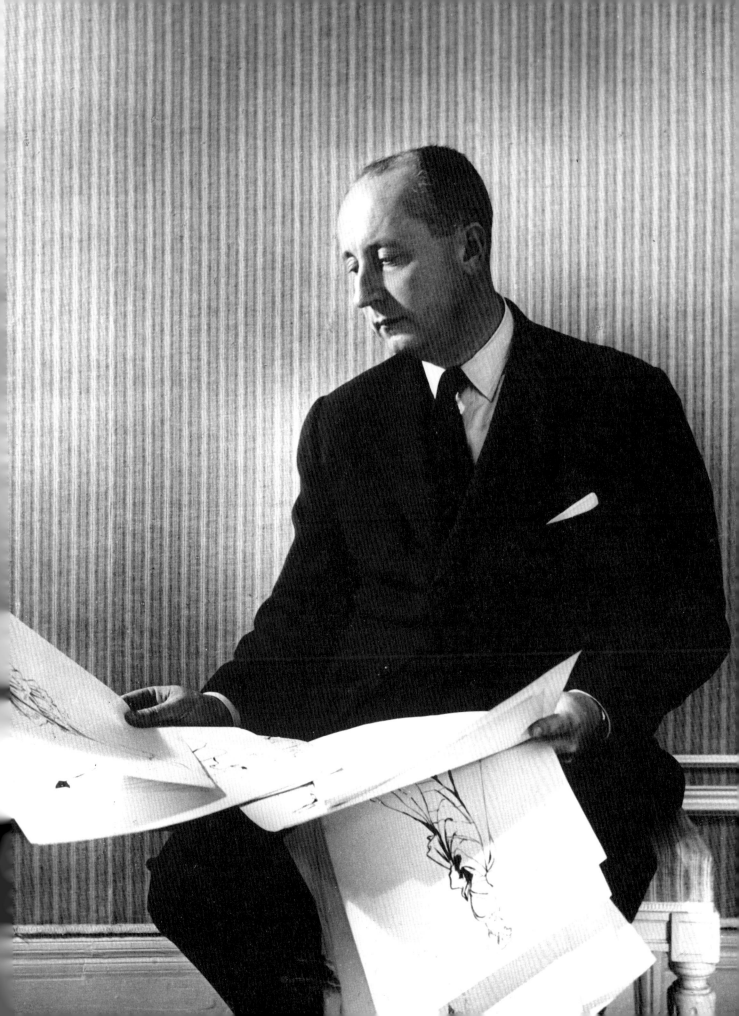

Yves Saint Laurent (1957-1960)

First came Yves Saint Laurent, who aged just 21, became the head designer immediately following Christian's death. His creations veered towards a fresher and softer style as his emblematic first collection, the Trapeze line in 1958 indicated. This marked a turning point in the company's history, undoubtedly reviving the company's financial fortunes. By the early 60s, the New Look had all but disappeared from the House of Dior collections. His bold designs were inspired, among other things, by the 1960s 'beatnik style'.

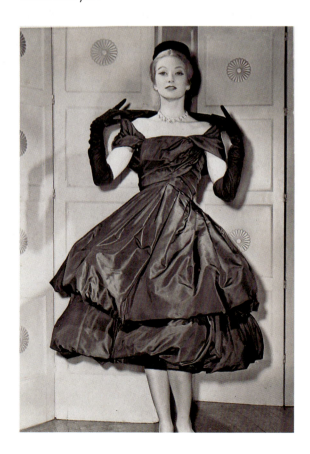

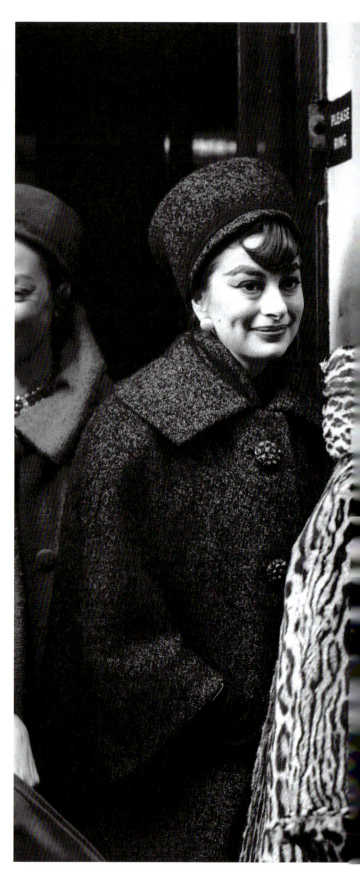

EPILOGUE

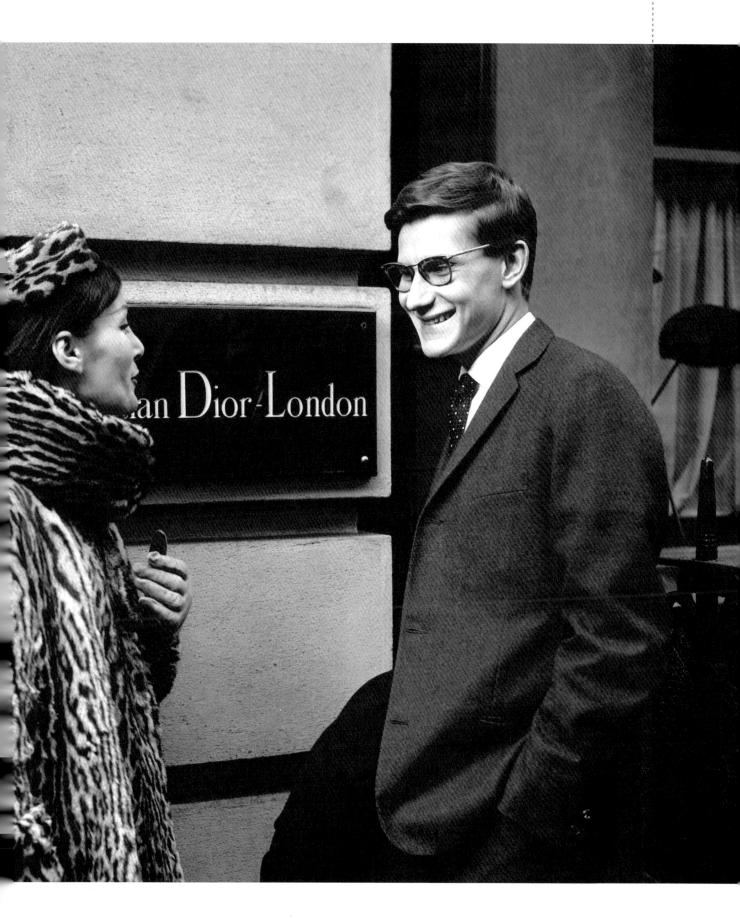

Marc Bohan (1960-1989)

In November 1960 Marc Bohan was appointed as creative director. His most famous creation was the 'Slim Look'. He stayed with Dior for almost 30 years, during which time the company became renowned for its contemporary interpretation of feminine designs and elegant silhouettes, more in line with Christian Dior's classic vision. It was under Bohan that the company established the menswear line, Dior Monsieur, in 1970.

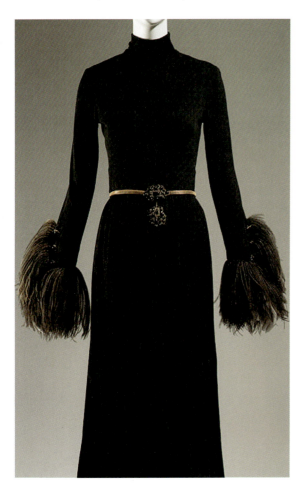

EPILOGUE 129

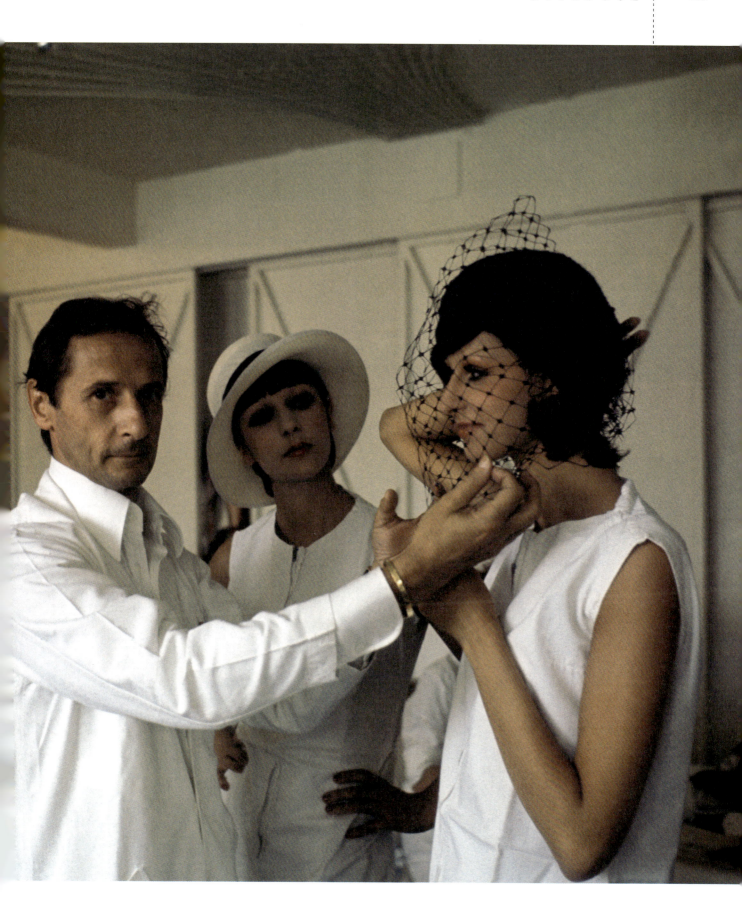

Gianfranco Ferré (1989-1997)

Becoming Creative Director of Dior women's collections in 1989, the Italian designer Gianfranco Ferré was the first non-Frenchman to head Dior.

Driven by his postmodern fashion vision, Ferré breathed new life into haute couture. His refined looks imposed an almost architectural elegance in his suit designs and added opulence to the brand's evening dresses. A passionate art lover, like Christian before him, Ferré was inspired by the palette of Paul Cézanne for his 1995-1996 autumn/winter Haute Couture collection.

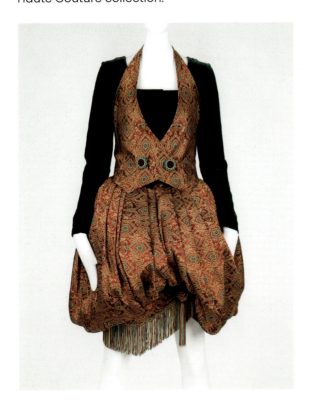

EPILOGUE 131

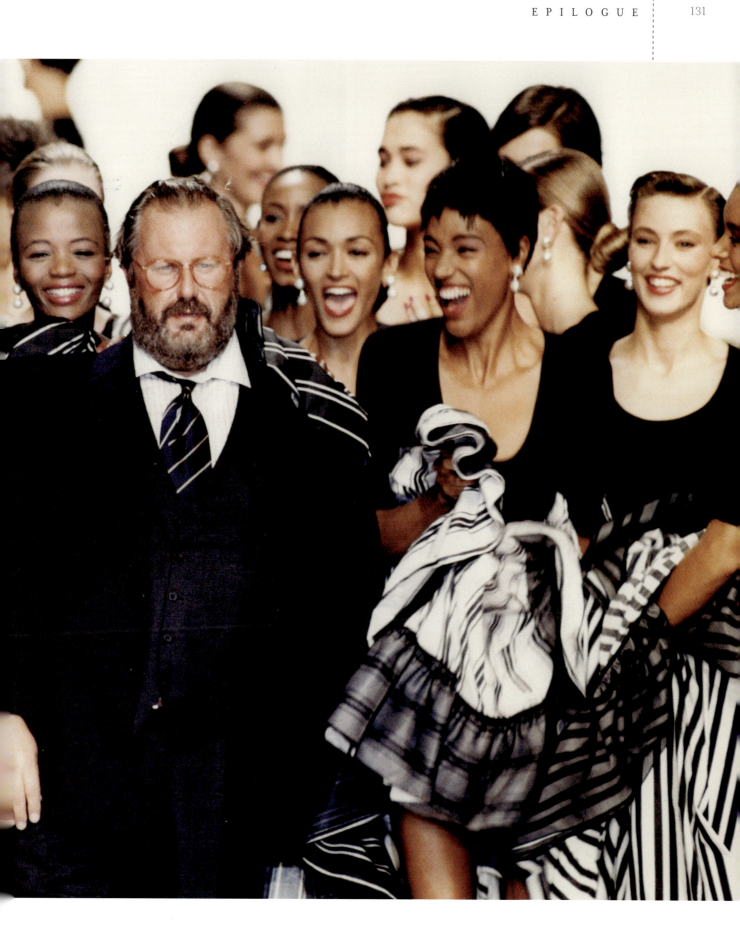

THE FASHION ICONS — DIOR

John Galliano (1997-2011)

British designer John Galliano was known for the extravagance and rock and roll flair of his work. His audacious and electrifying designs reinvented the Dior haute couture tradition, and his shows were 'must watch' events, notable not least for the sheer spectacle they provided. Diana, Princess of Wales became a fan, particularly of his handbag designs, which helped to boost sales of Dior's leather goods. She reportedly gave her blessing to a design known as the Lady Dior bag. When Galliano left Dior, the next four collections were designed by his assistant designer Bill Gaytten.

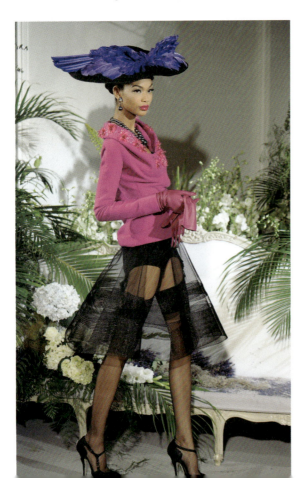

EPILOGUE 133

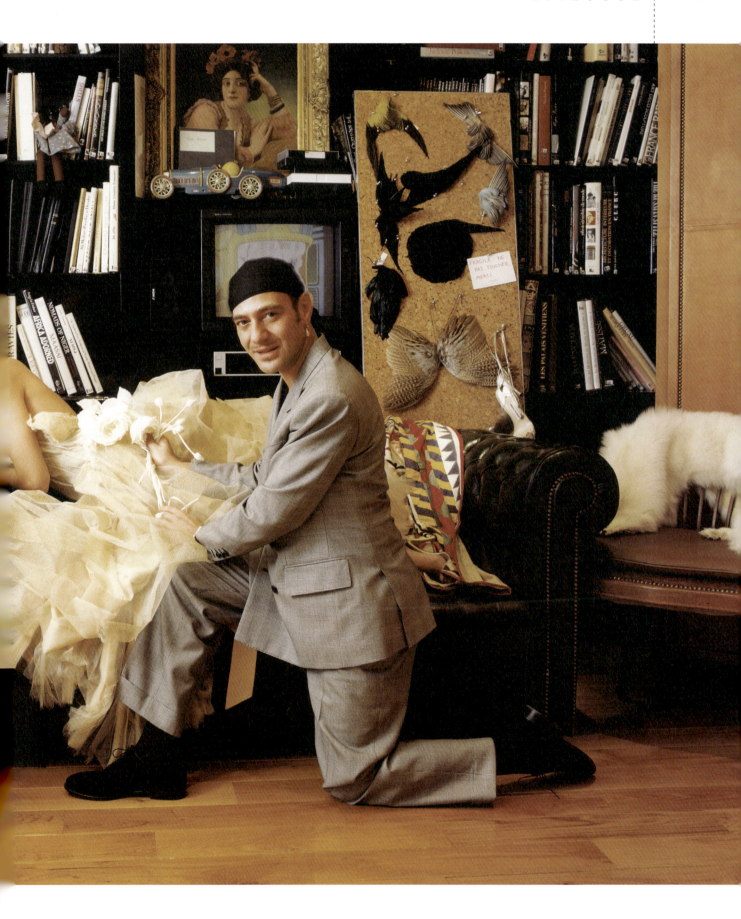

Raf Simons (2012-2015)

The Belgian designer Raf Simons had a refined, minimalist signature style, again moving the brand closer to the ideals of its founder. His collections frequently reinterpreted Christian Dior's curvaceous 'flower-woman', transforming her into an architectural silhouette.

Determinedly contemporary, he even revisited the original 'New Look' interpreted as a pantsuit. When he left, the interim directors were Serge Ruffieux and Lucie Meier.

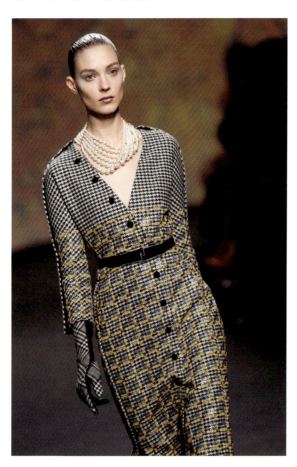

EPILOGUE 135

THE FASHION ICONS | DIOR

Maria Grazia Chiuri
(2016 - currently)

As Dior's first female Creative Director, Maria Grazia Chiuri has promoted youthful, feminist designs with her bold vision. By collaborating with artists the world over, she has woven all types of knowledge and cultural influences into her work. Word is that she has taken the brand from feminine to feminist.

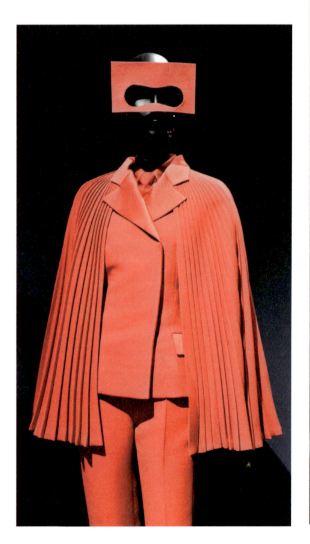

EPILOGUE 137

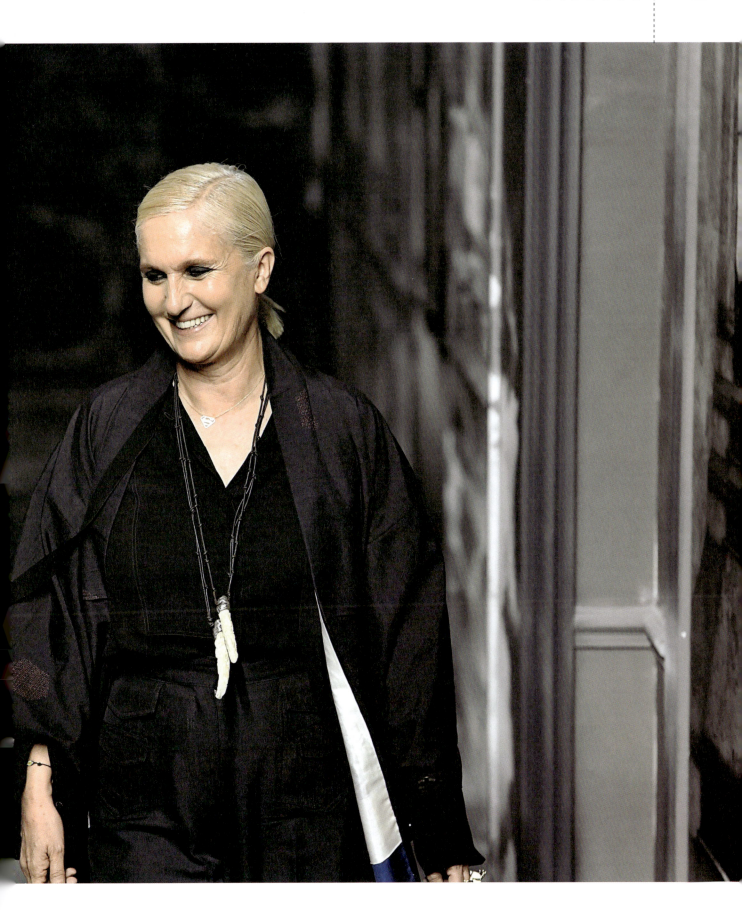

Dior Homme

Dior's menswear division and label has been called Dior Homme and Dior Men. For a time in the 1980s and 1990s it was called Dior Monsieur.

It was named Dior Homme in 2000 with **Hedi Slimane** appointed as its first dedicated creative director, replacing lead designer Patrick Lavoie. Under Slimane, the brand became known for a signature slim silhouette with a moody aesthetic. Stars such as Mick Jagger and Brad Pitt were fans of the look.

In 2007, **Kris Van Assche** took over from Slimane, bringing in more formal, minimalistic designs. Over the years he favoured models with an athletic look to beef up the Dior Men silhouette. His designs hinted at the merging of streetwear and tailoring which would follow.

In March 2018, the Dior menswear line was renamed Dior Men and **Kim Jones** was appointed as creative director. He's taken a 'pop' approach to his designs, for example partnering with street artist KAWS for his debut show during Paris Fashion Week.

As a world-leading luxury house, it's natural that Dior's range would expand. Today, along with haute couture, Dior now has ranges of ready to wear fashion, jewellery, make up and, of course, many more fragrances have been added to the company's perfume wardrobe in the years since Christian's death.

ABOVE L-R: Hedi Slimane; Kris Van Assche; Kim Jones
RIGHT: Dior Homme Winter 2014 Collection

EPILOGUE | 139

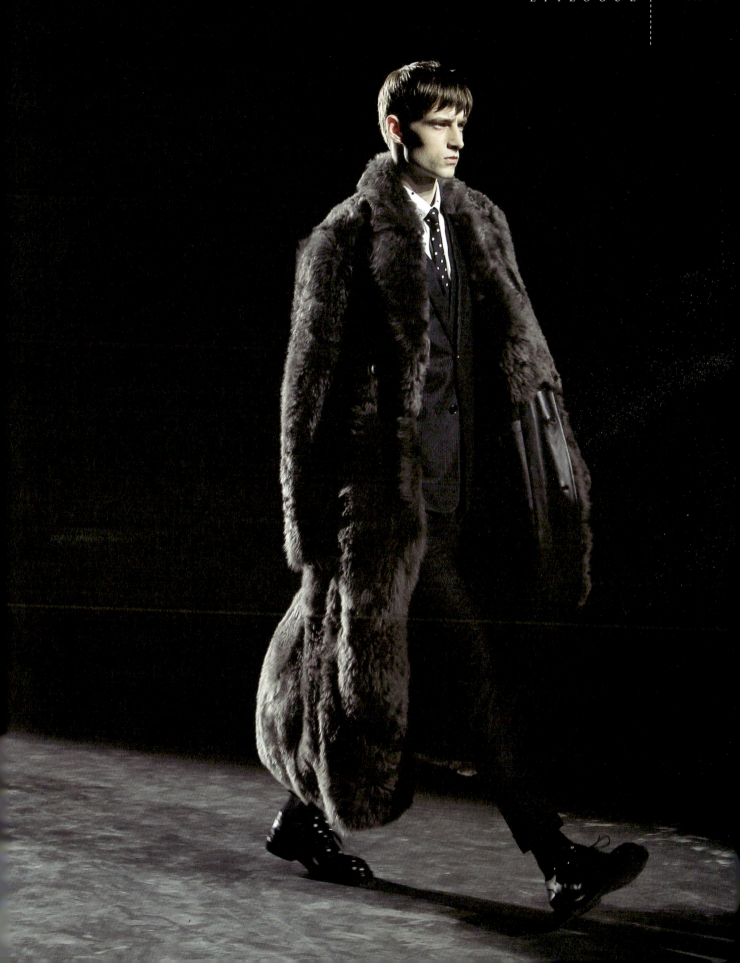

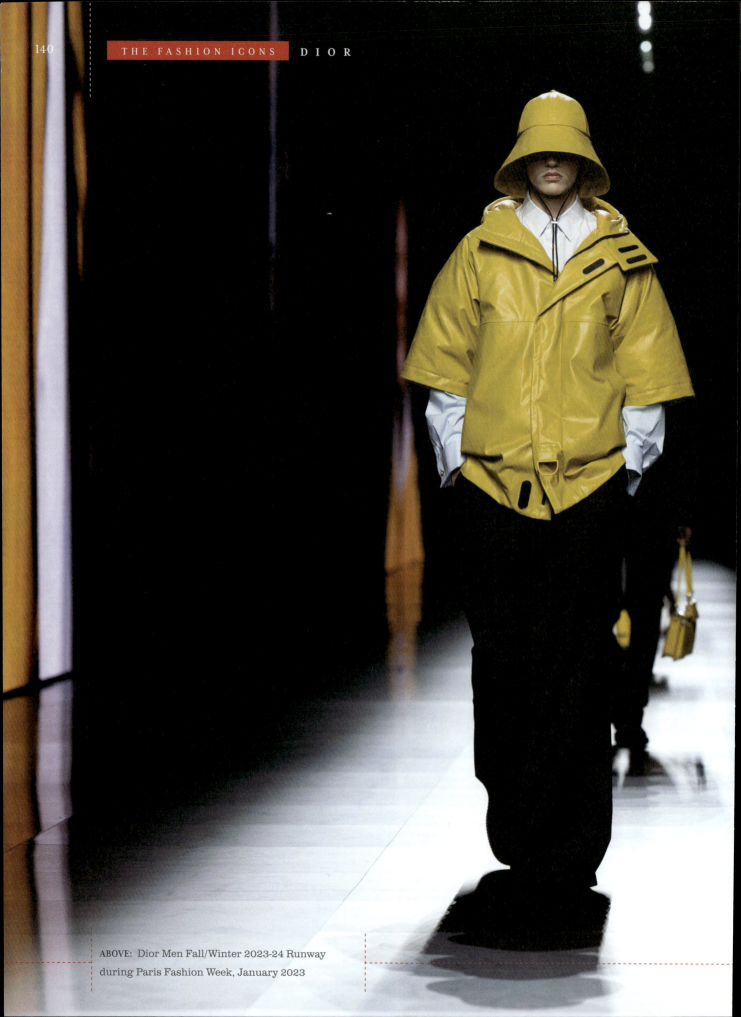

ABOVE: Dior Men Fall/Winter 2023-24 Runway during Paris Fashion Week, January 2023

EPILOGUE 141

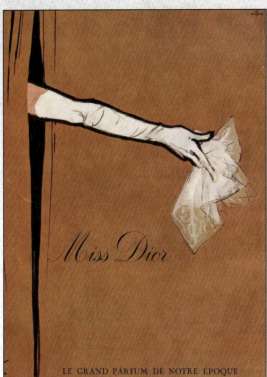

Dior fragrances

Since Miss Dior was created in 1947, Dior fragrances for women and men have continued to make their mark in the industry, where they are recognised as high quality and timeless scents.

- Poison
- J'adore
- Dior Homme
- Joy
- Addict
- Diorissimo
- Miss Dior Absolutely Blooming
- Dior Sauvage
- Dior Amour
- Gris Dior